Art Nouveau

Coloring for Everyone

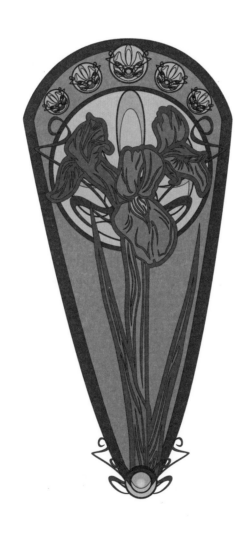

Skyhorse Publishing

Art Nouveau:
Coloring for Everyone

We all remember the joys and agonies of coloring books from our childhoods. You either stayed inside the lines or you did not. For some of us, this was a choice; for others, we were just not very good. But now, you have the opportunity to rediscover your inner child who still finds joy in the activity. There are real benefits to coloring as we get older, as well. It can be a creative outlet, it can help relieve stress, and it can improve our hand-eye coordination—and let's not forget that we are creating something artistic and beautiful.

There are many mediums through which coloring can be explored, and coloring books are one of those ways. But many coloring books can be too simple for an adult, so we present to you a collection of art nouveau designs that offer more intricate patterns and figures.

Art nouveau is a movement that changed the decorative arts and architecture in the late 19th and early 20th centuries. It generated enthusiasts throughout the Western world and beyond, consisting of a wide variety of styles. Consequently, it is known by various names, such as the Glasgow Style, or, in the German-speaking world, Jugendstil. Art Nouveau was aimed at modernizing design, seeking to escape the systemized historical styles that had previously been popular. Artists drew inspiration from both organic and geometric forms, evolving intricate and unique designs that united flowing, natural forms with more angular contours. The movement was committed to abolishing the traditional hierarchy of the arts, which viewed so-called liberal arts, such as painting and sculpture, as superior to craft-based decorative arts, and ultimately it had far more influence on the latter. Art nouveau went out of fashion after it gave way to the Art Deco

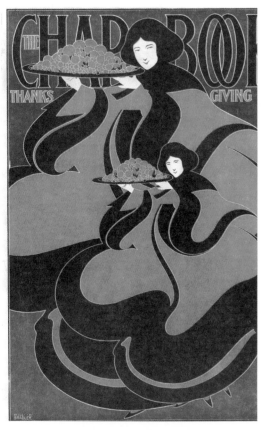

The Chap Book–Thanksgiving no." "Art nouveau illustration showing two women holding trays of food." 1895. Library of Congress. Bradley, Will, 1868–1962, artist.

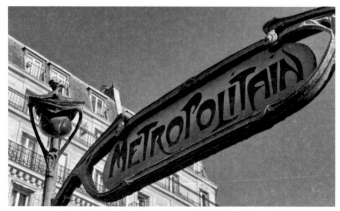

Famous historic Art Nouveau entrance sign for the Metropolitain underground railway system in Paris, France.

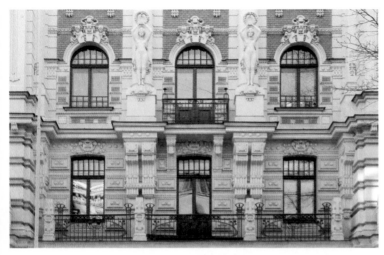

Art Nouveau architecture in Riga, Latvia that highlights the unique style that emerged in the late 19th century.

movement in the 1920s, but it experienced a popular revival in the 1960s, and it is now seen as an important predecessor to modernism.

This book offers a beautiful collection of art nouveau designs for you to color, allowing you explore your creative and artistic side. The designs vary from relatively simple to complex, giving you the opportunity to improve your technique and test the limits of your creativity. The art nouveau styles allows for a wide range of designs and images, so this book definitely has pieces that will inspire your creative genius.

The designs are printed on only one side of the page, and the pages are each perforated so they can be removed from the book to make coloring easier (as well as to allow you to use them as decoration). There are also colored examples of each of the designs in the front of the book, which can give you some ideas and inspiration on color palettes and how to use them. The fun of coloring, though, is to use your own colors and outside inspirations. The first step in coloring is to select what you want to use for the coloring process. You may want to use crayons, colored pencils, or marking pens. Use the blank stripes in the back of the book to test your coloring medium, as well as color combinations. Once you have selected a range of colors that can be used for the coloring, you are ready to begin.

Art nouveau is a movement that changed the face of the art world and now you can enjoy and experience it like never before. Enjoy!

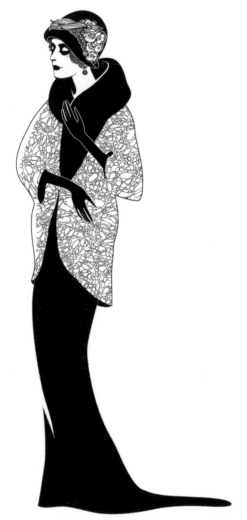

Art nouveau lady in black and white that exemplifies the simple yet refined drawings of the art nouveau movement.

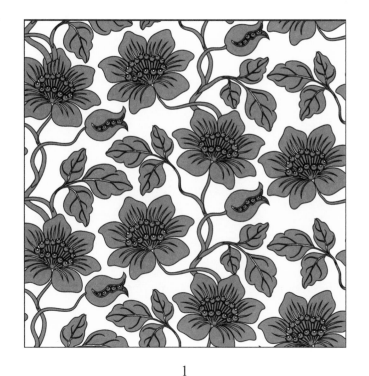

1

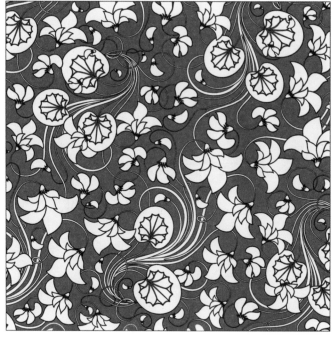

2

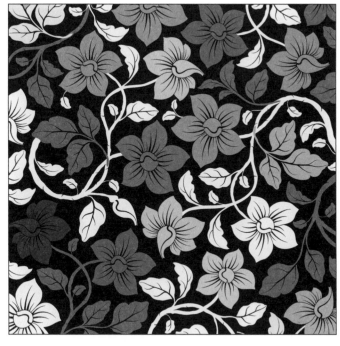

3

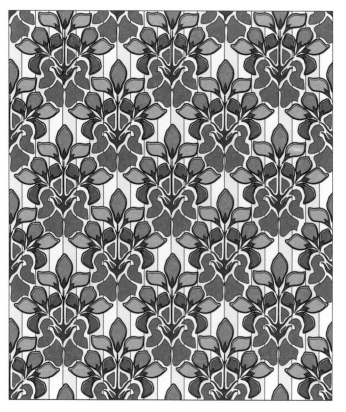

4

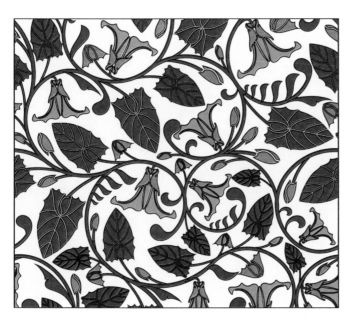

5

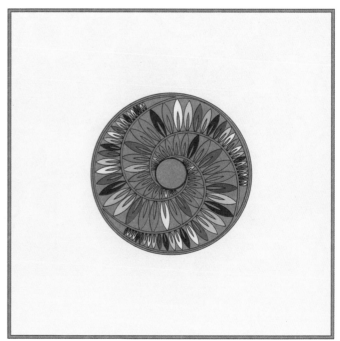

6

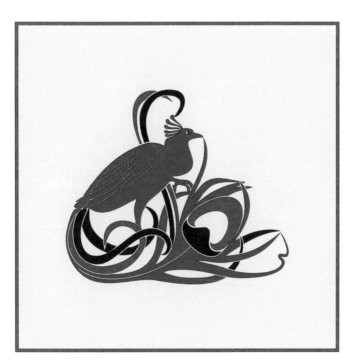

7

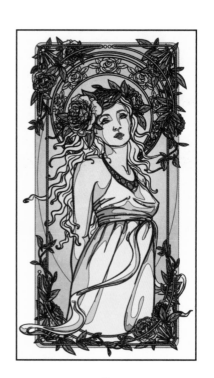

8

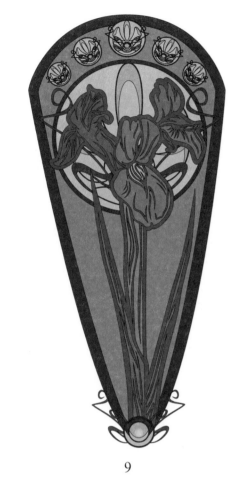

9

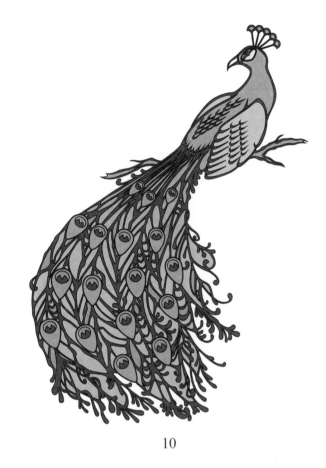

10

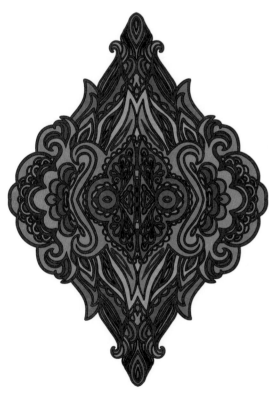

11

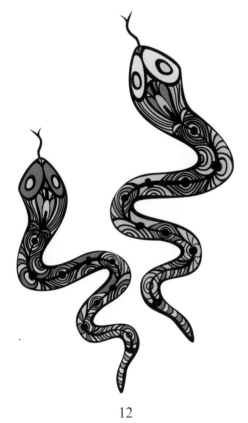

12

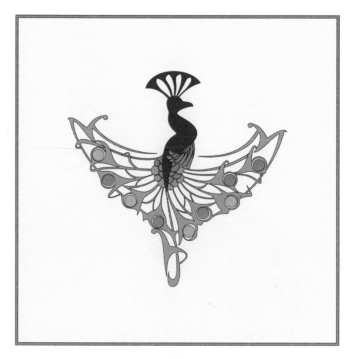

13

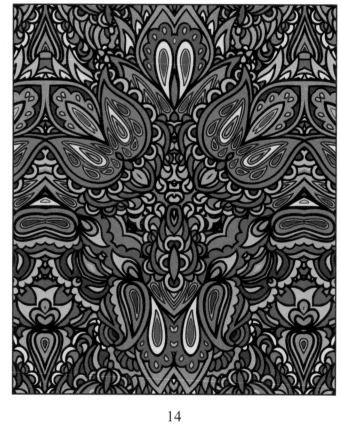

14

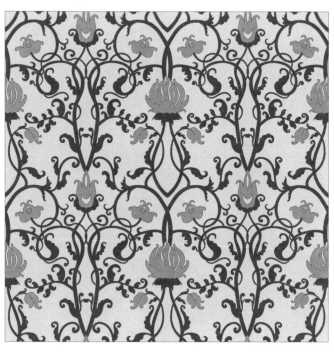

15

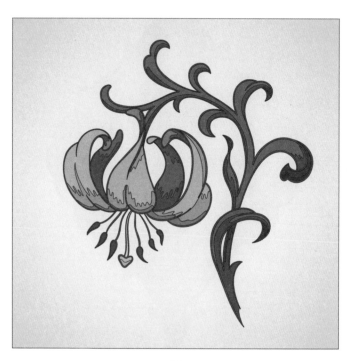

16

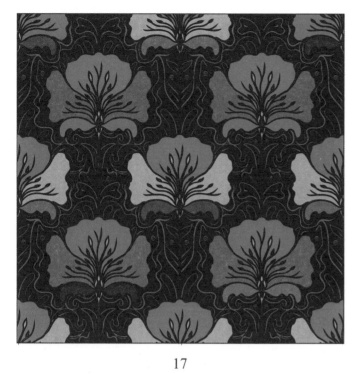

17

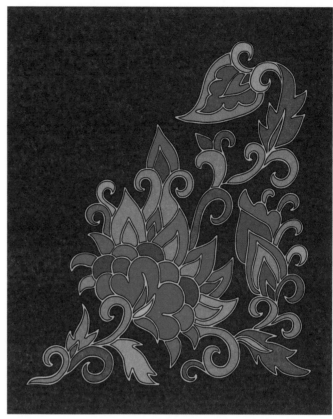

18

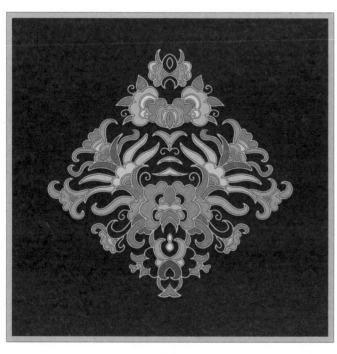

19

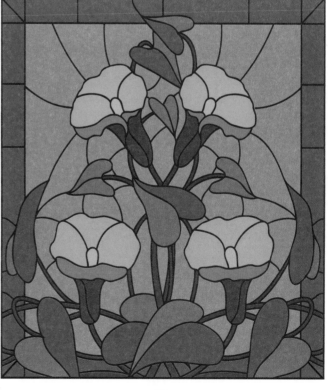

20

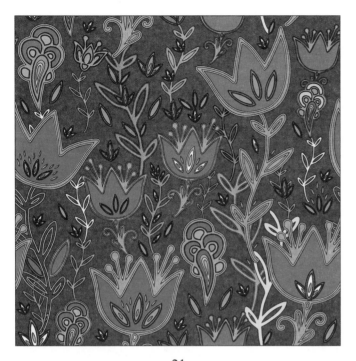

21

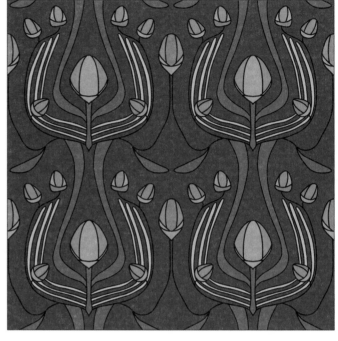

22

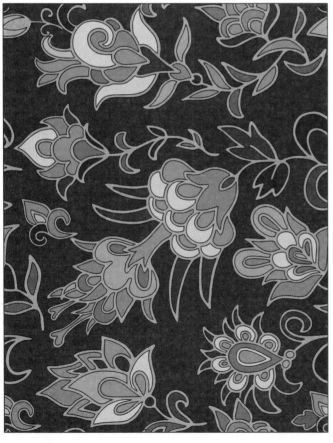

23

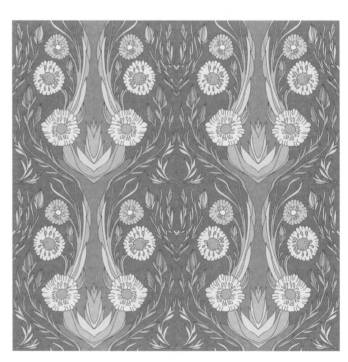

24

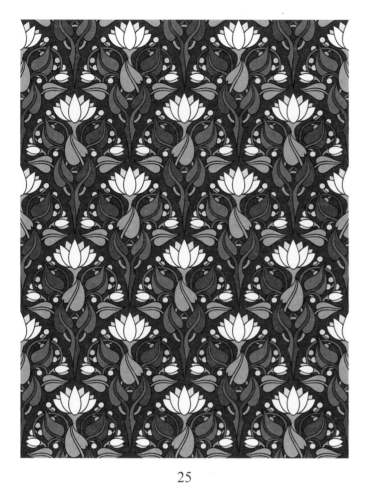

25

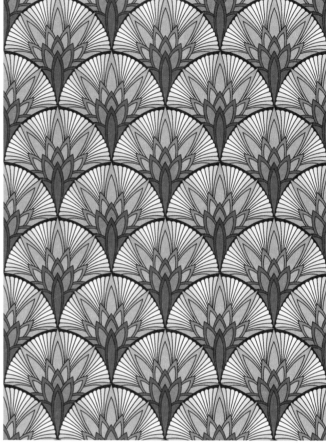

26

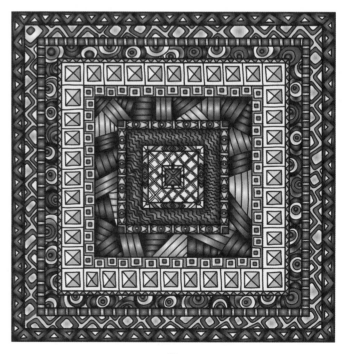

27

28

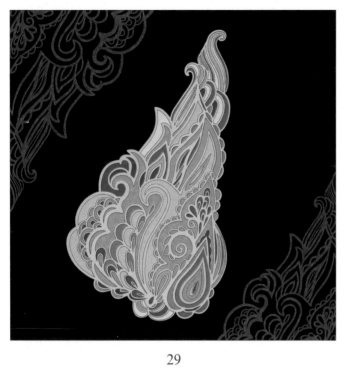

29

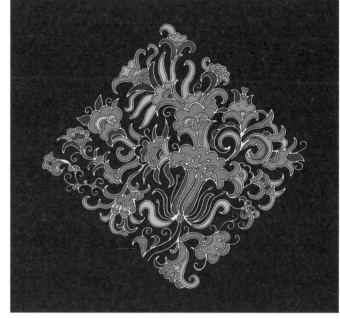

30

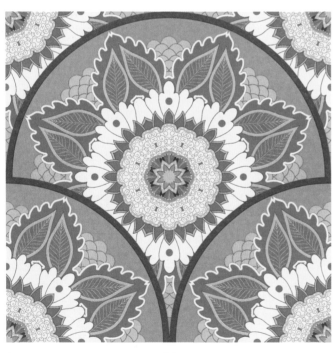

31

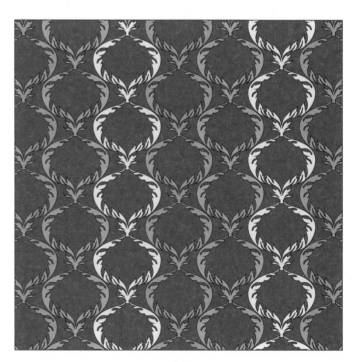

32

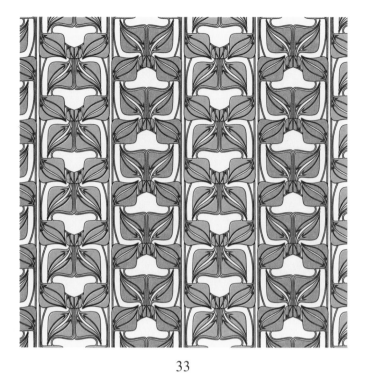

33

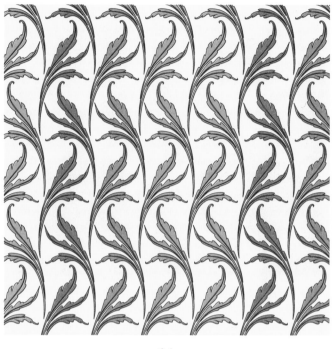

34

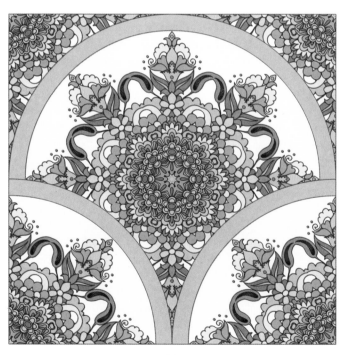

35

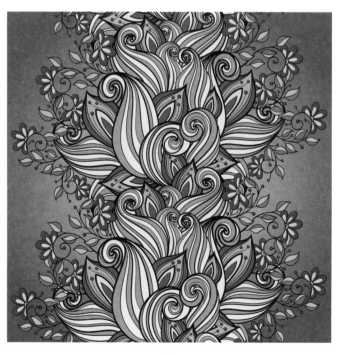

36

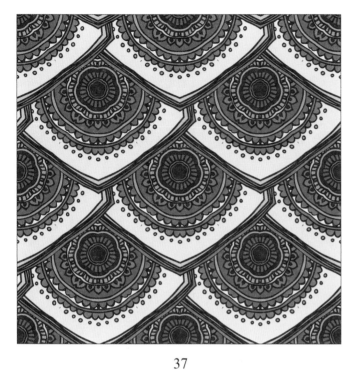

37

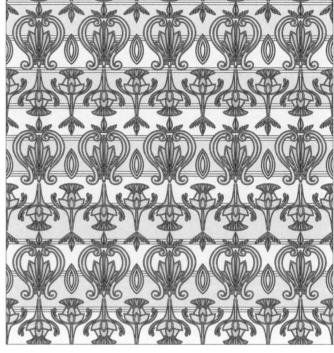

38

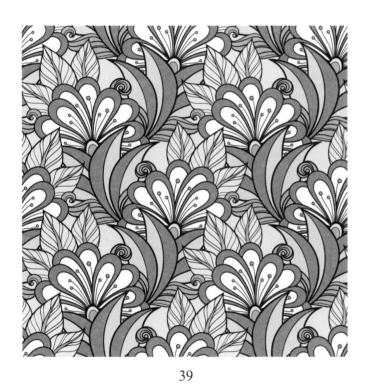

39

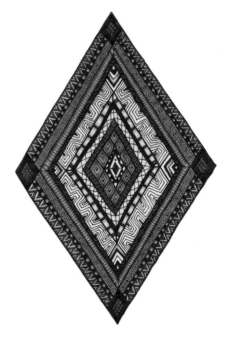

40

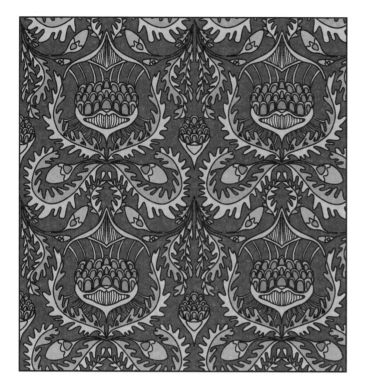

41

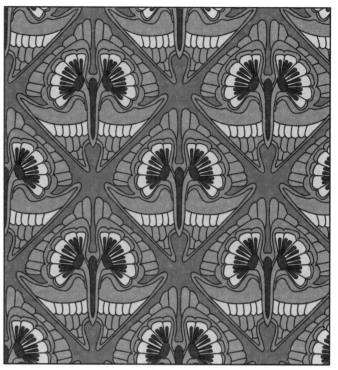

42

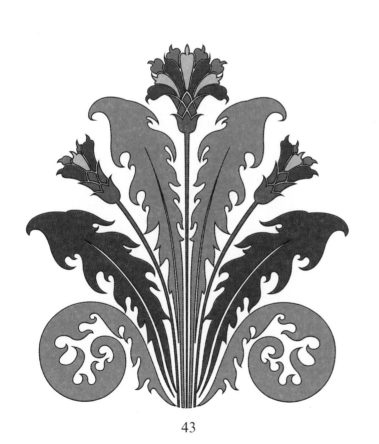

43

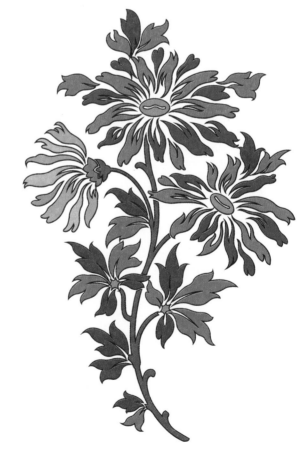

44

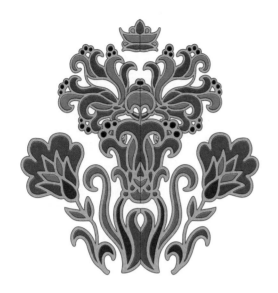

45

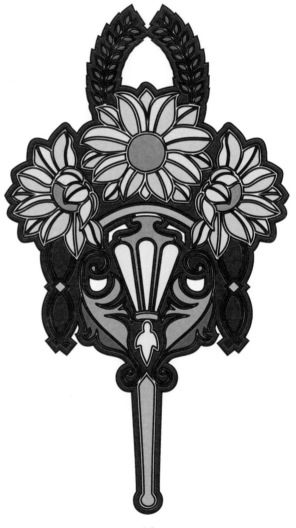

46

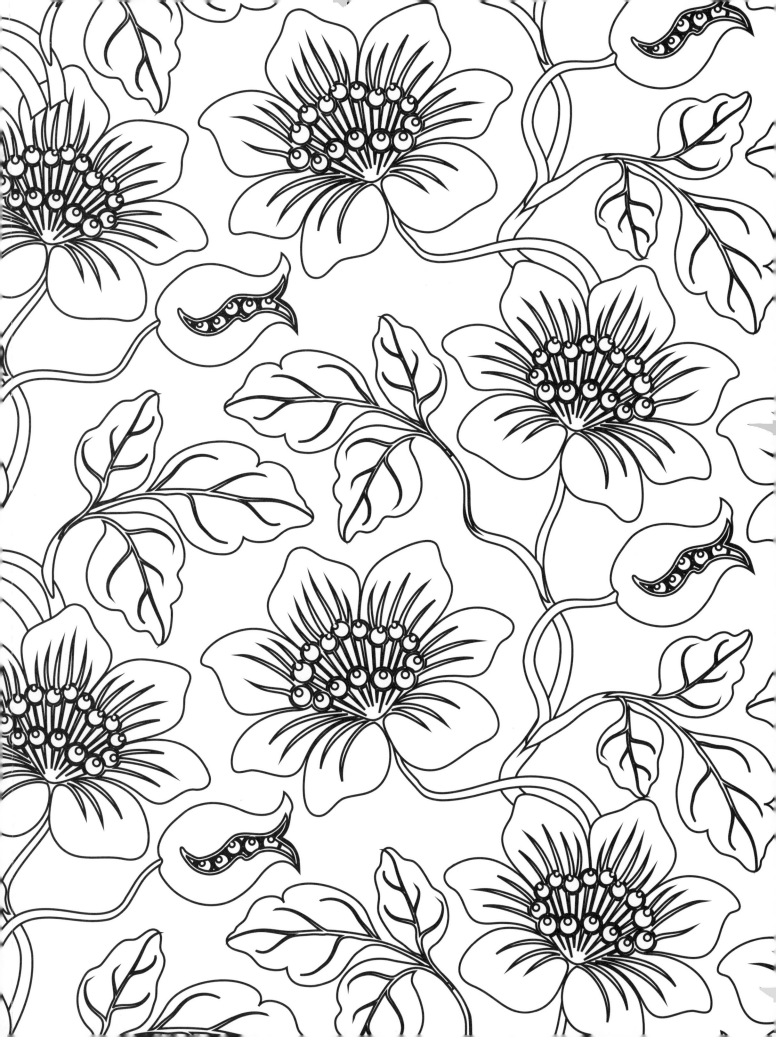

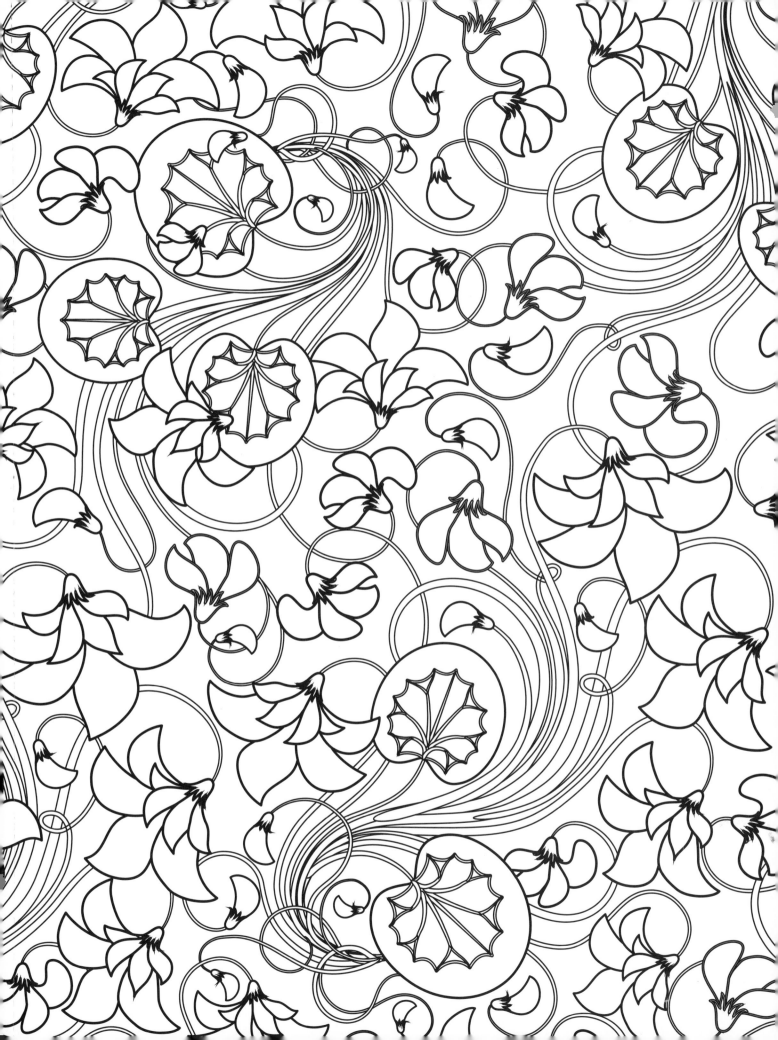

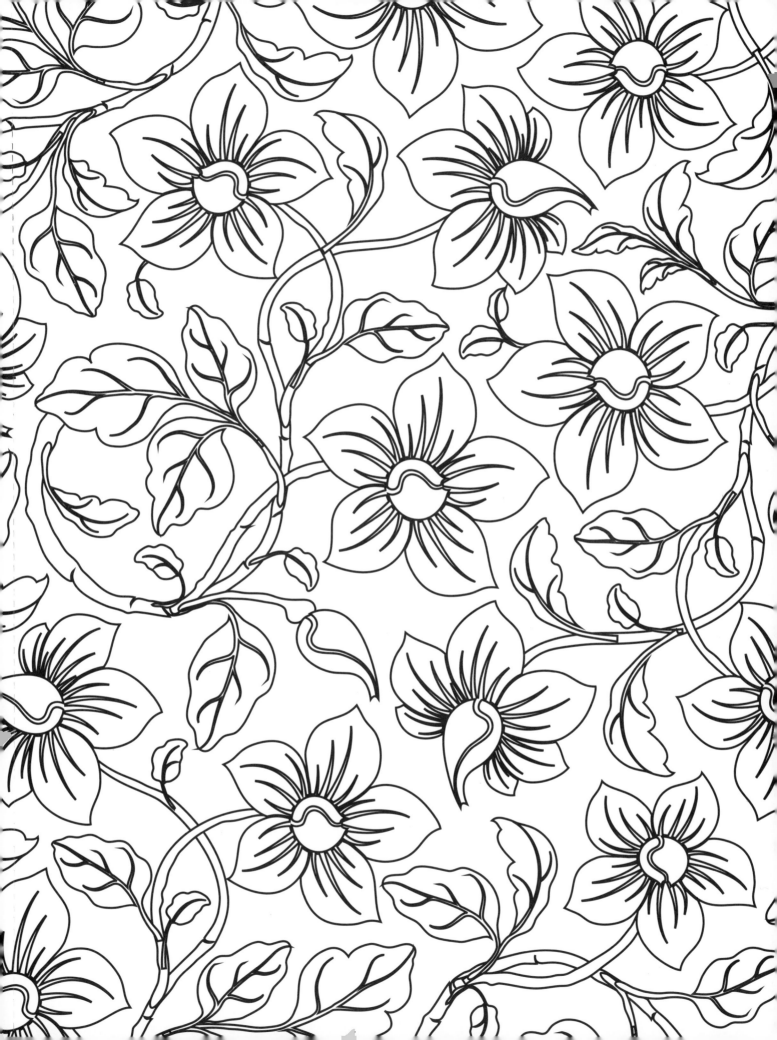

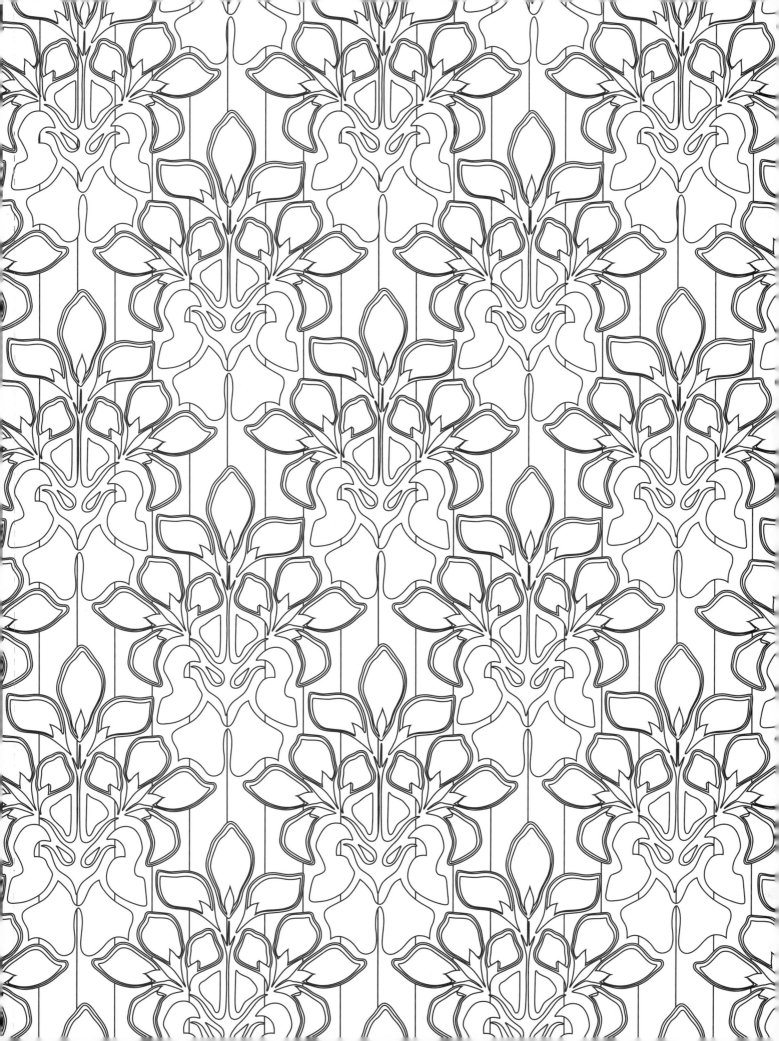

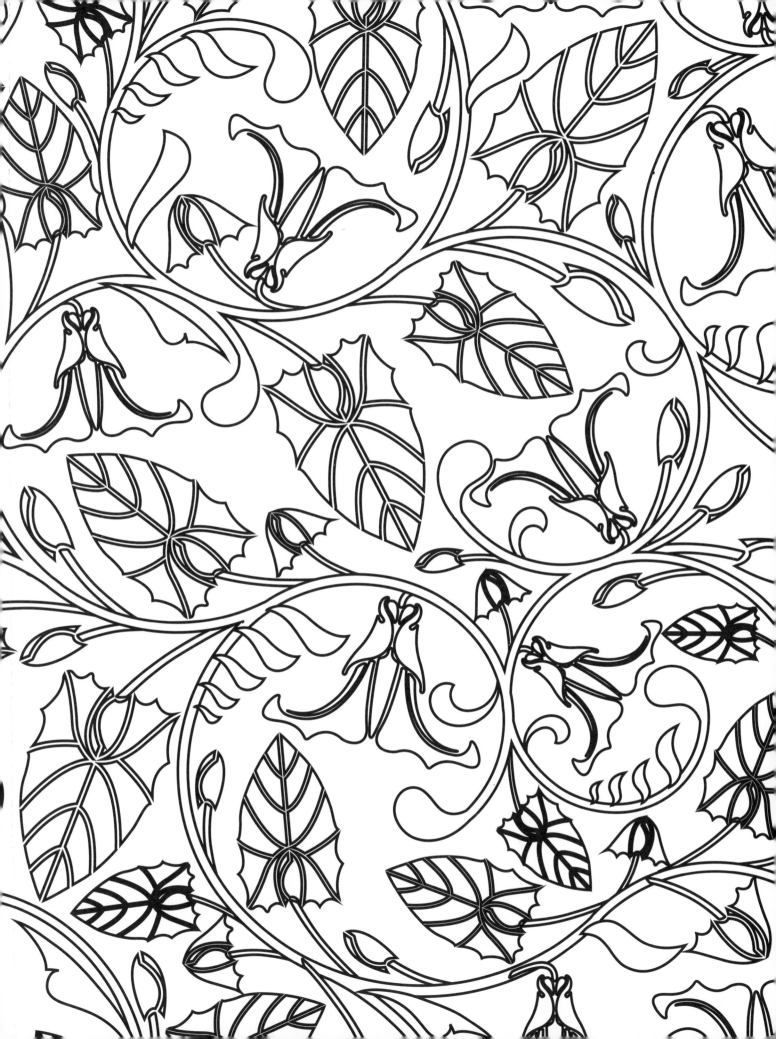

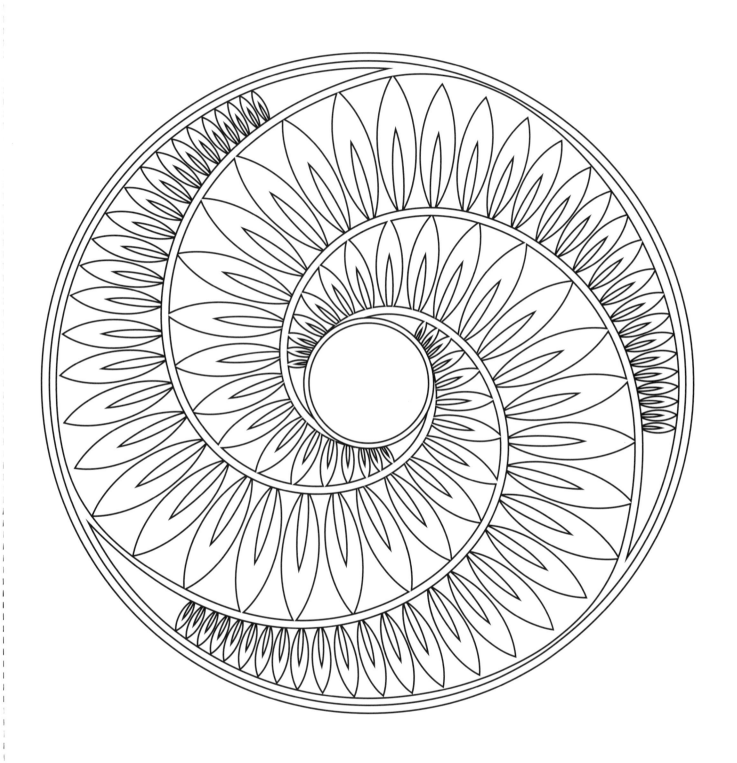

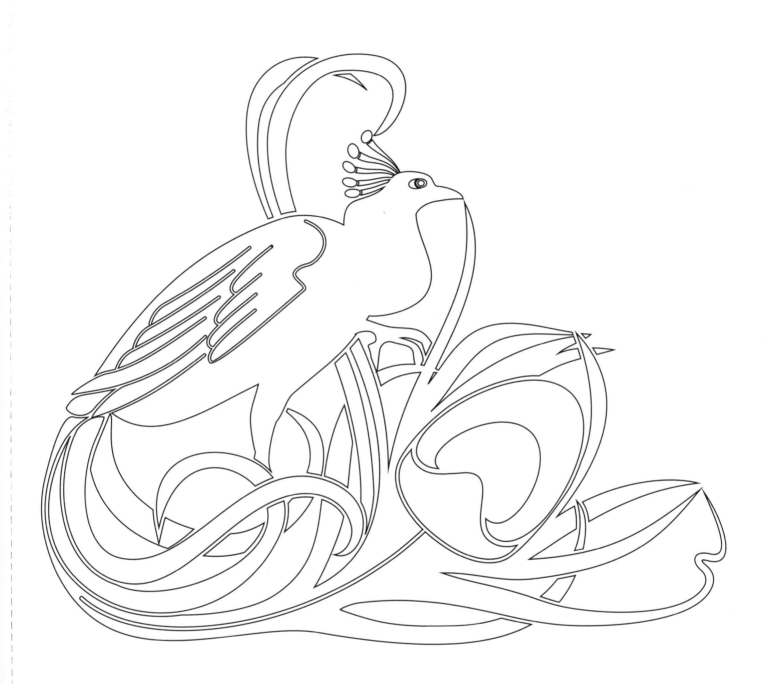

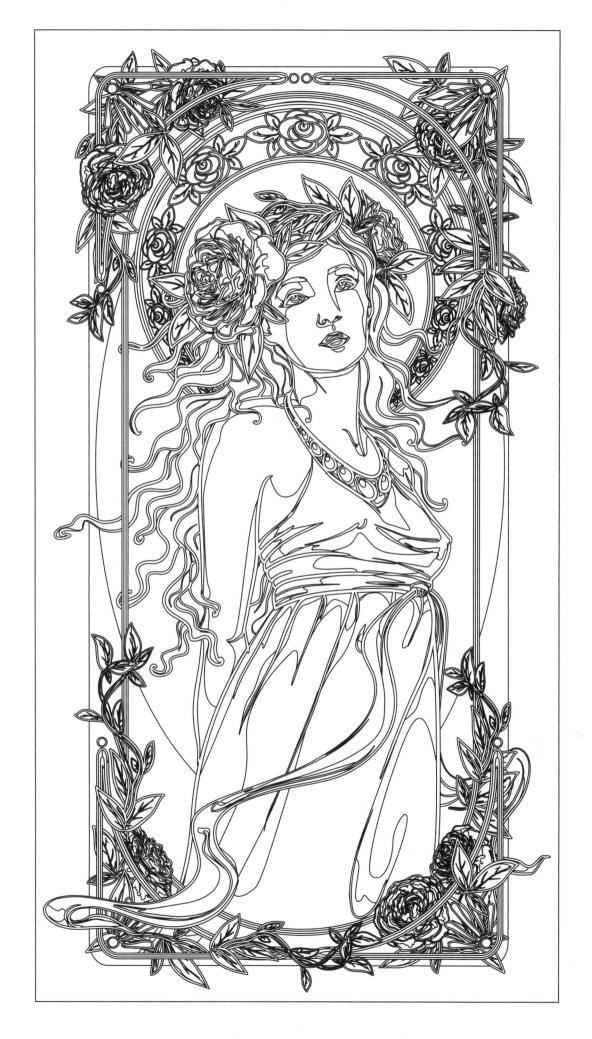

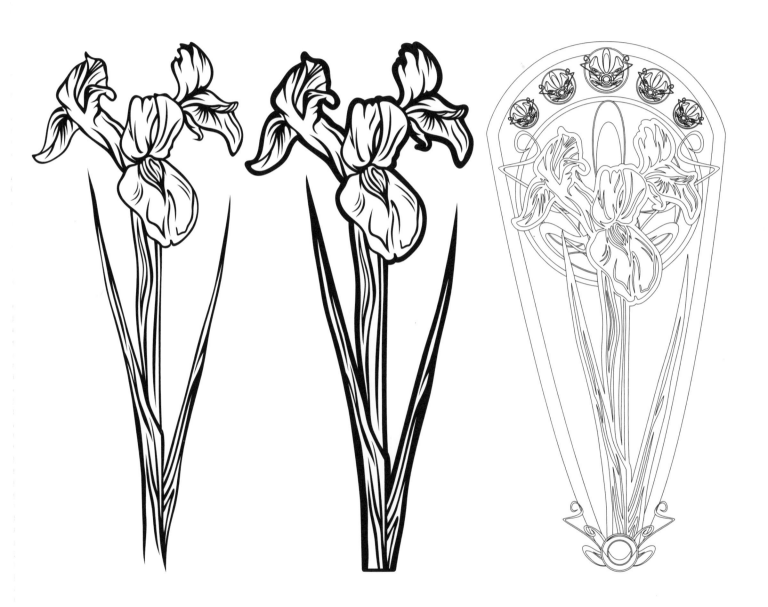

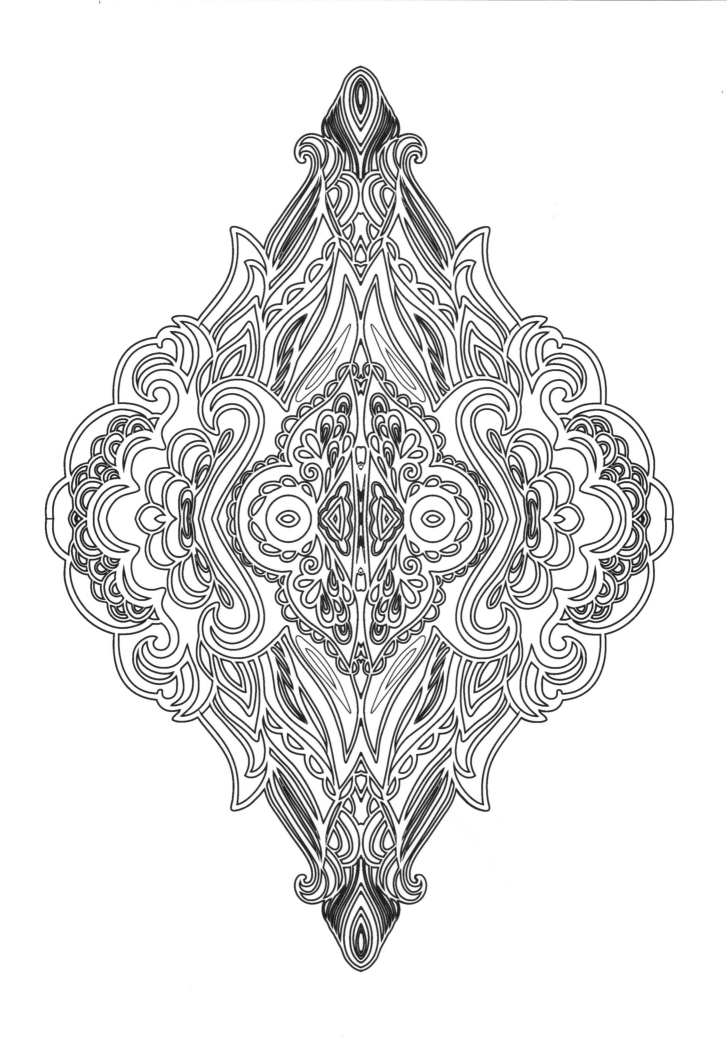

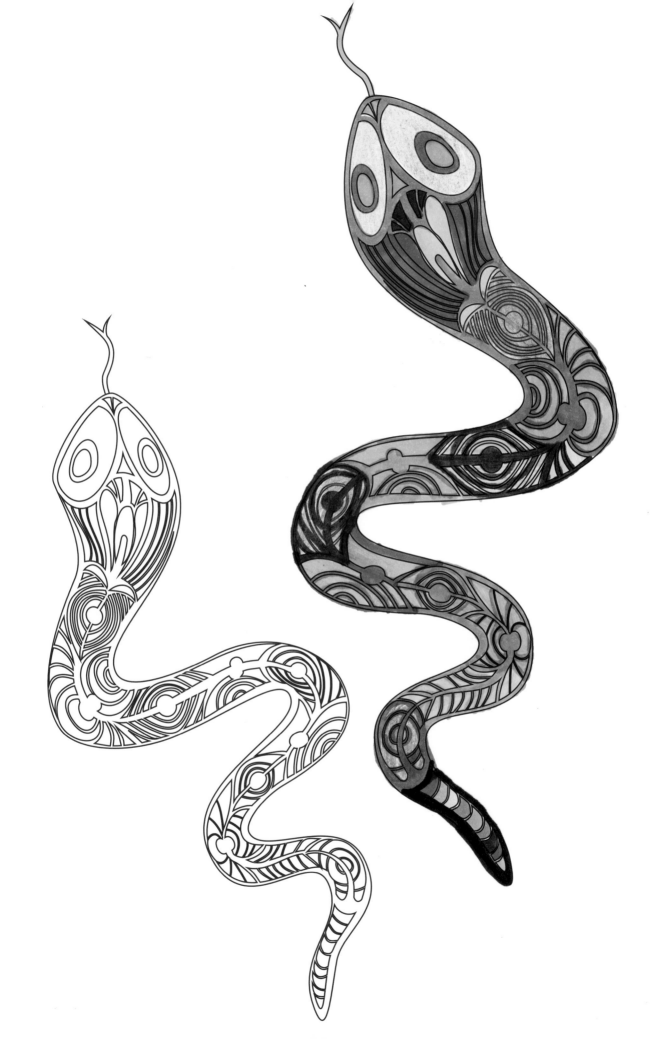

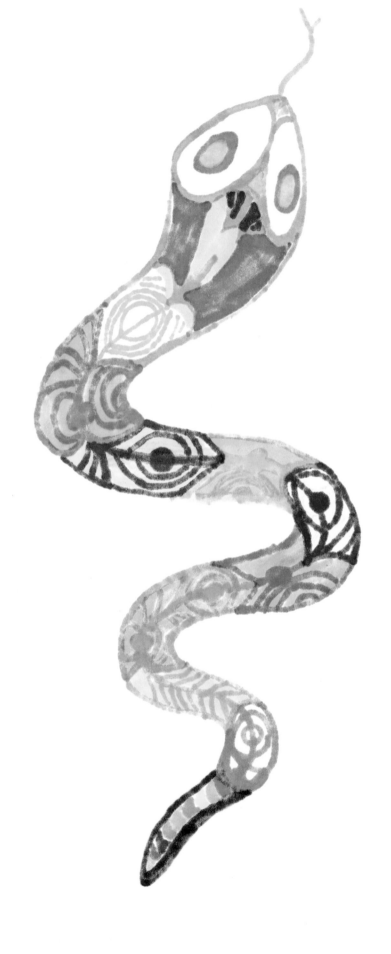

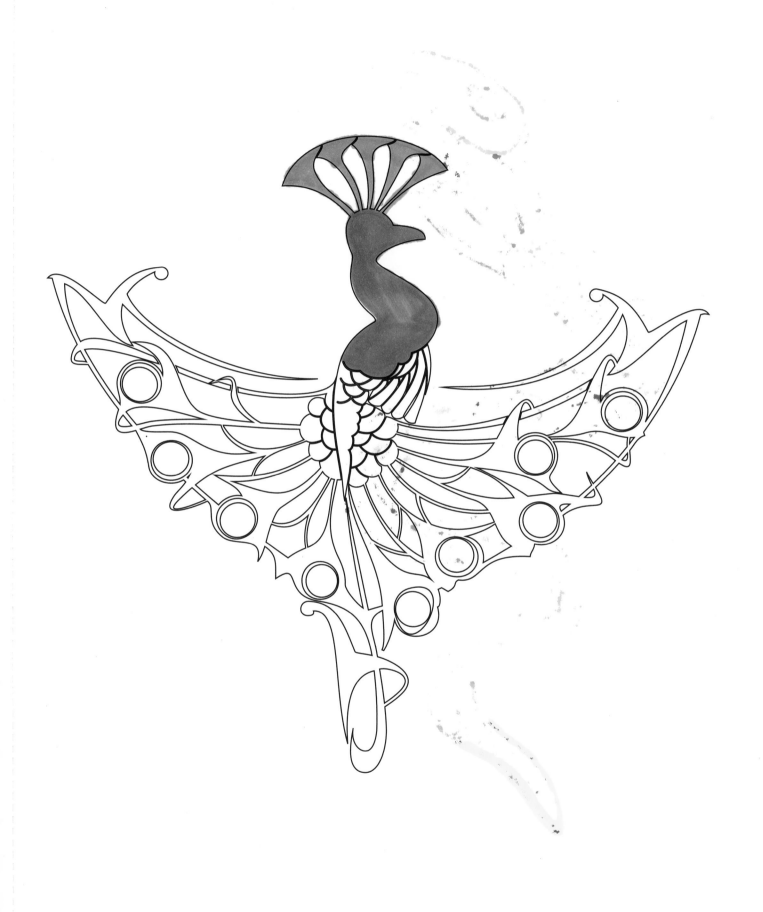

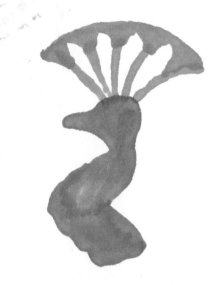

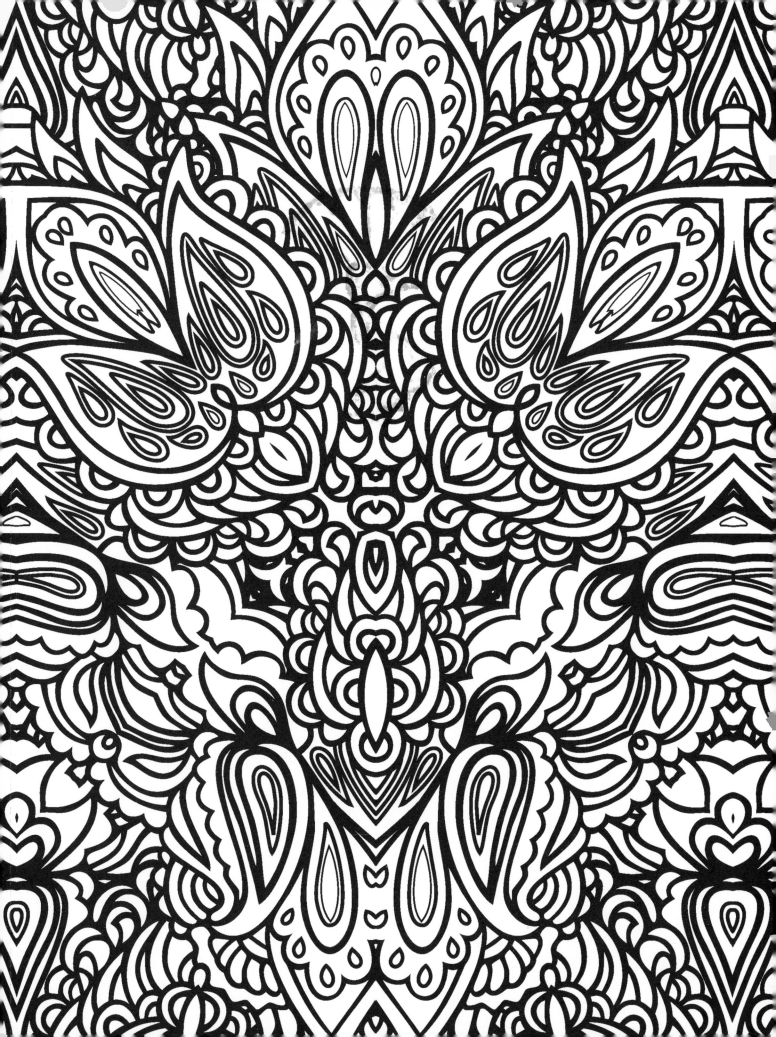

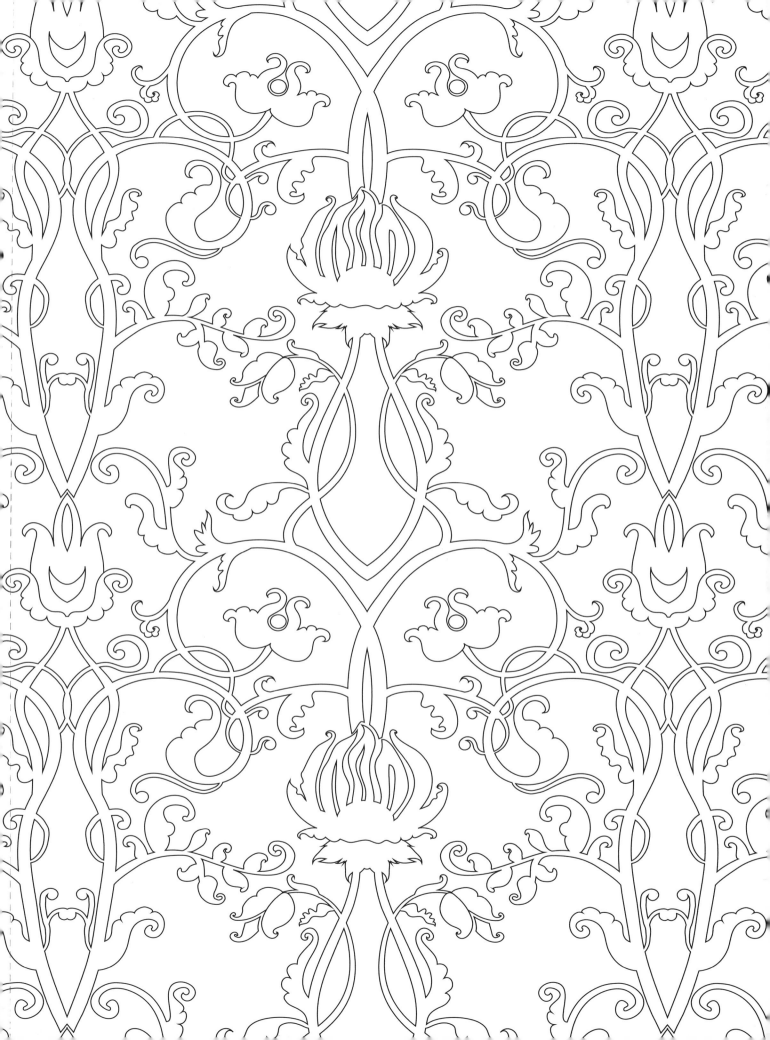

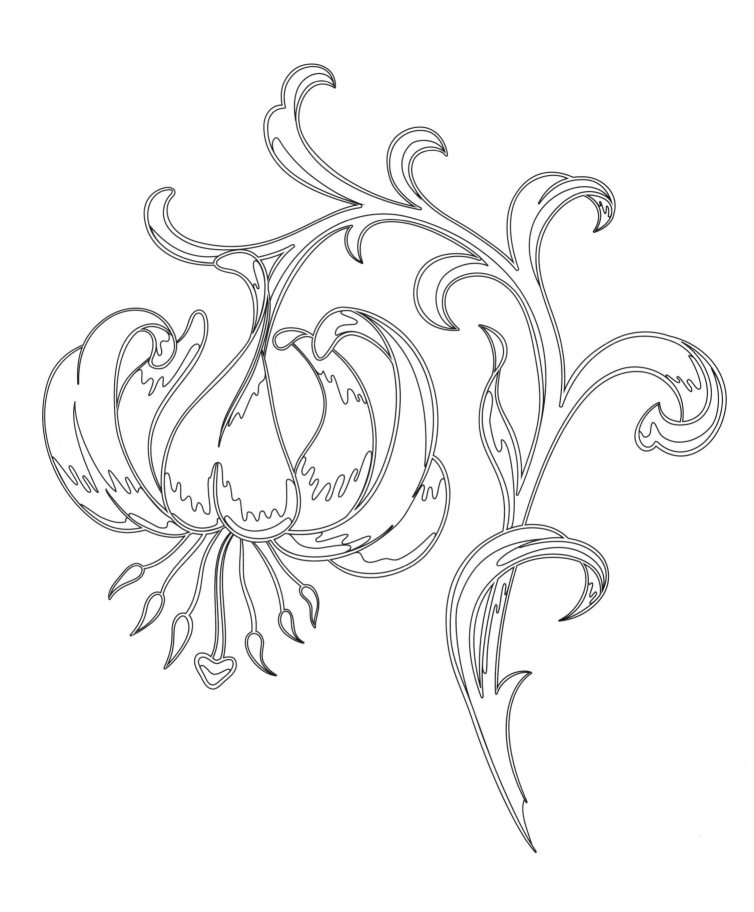

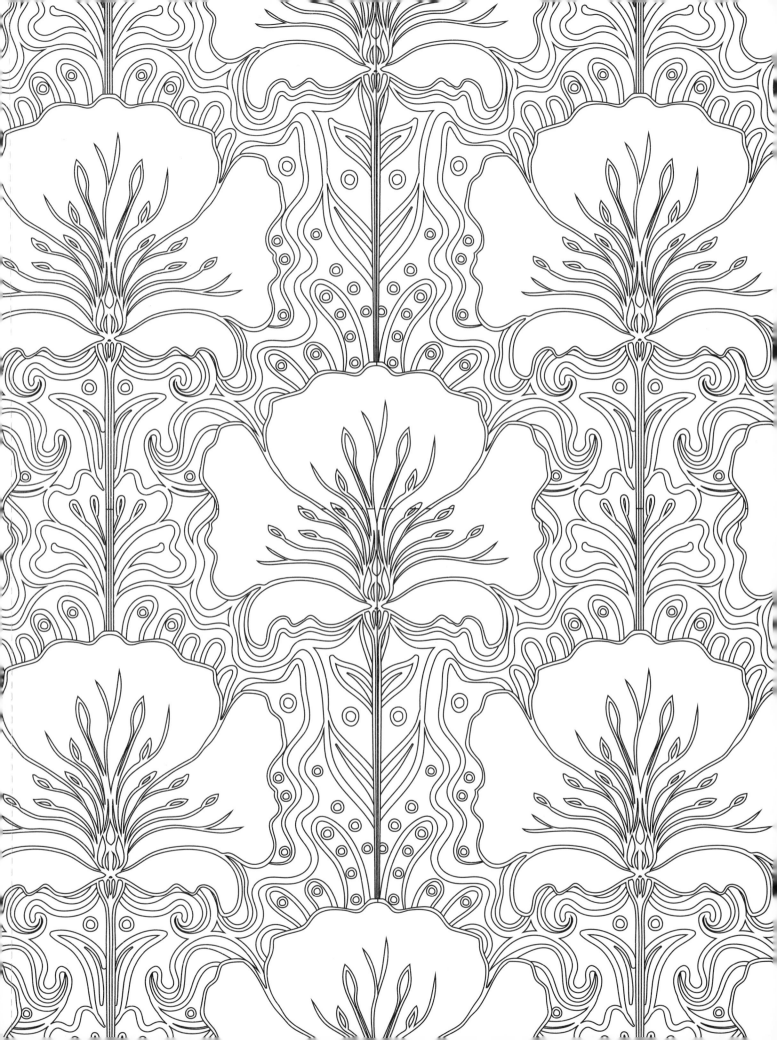

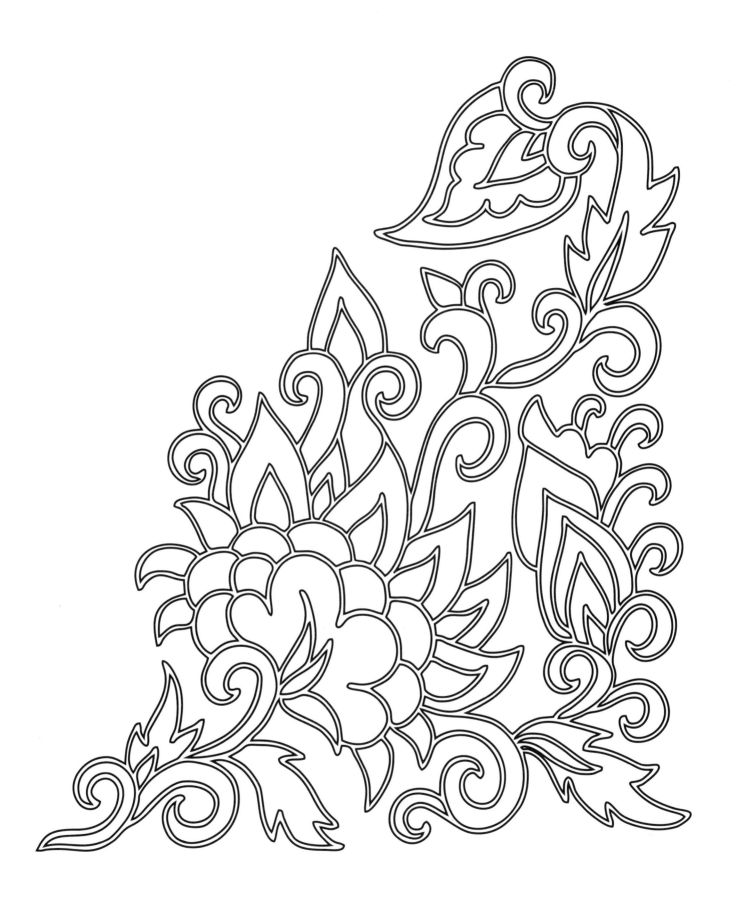

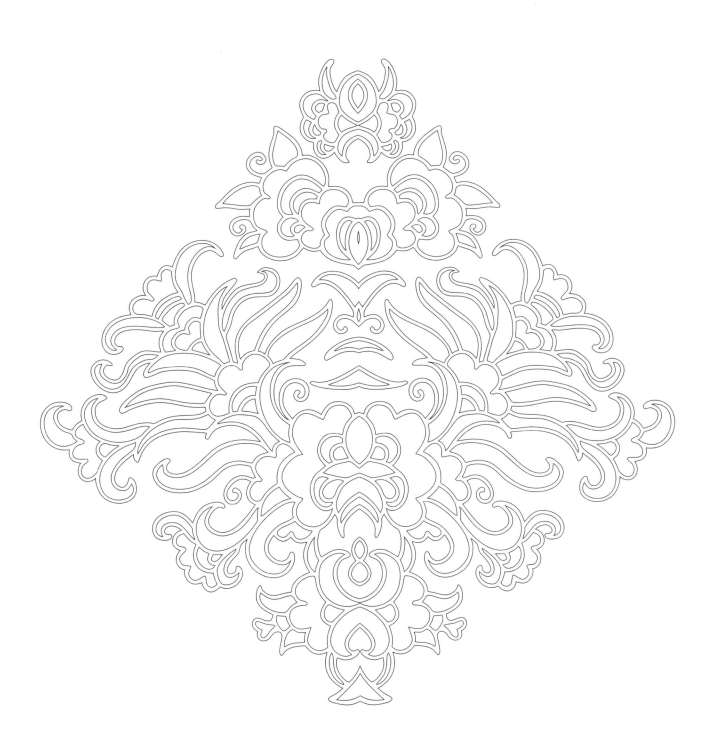

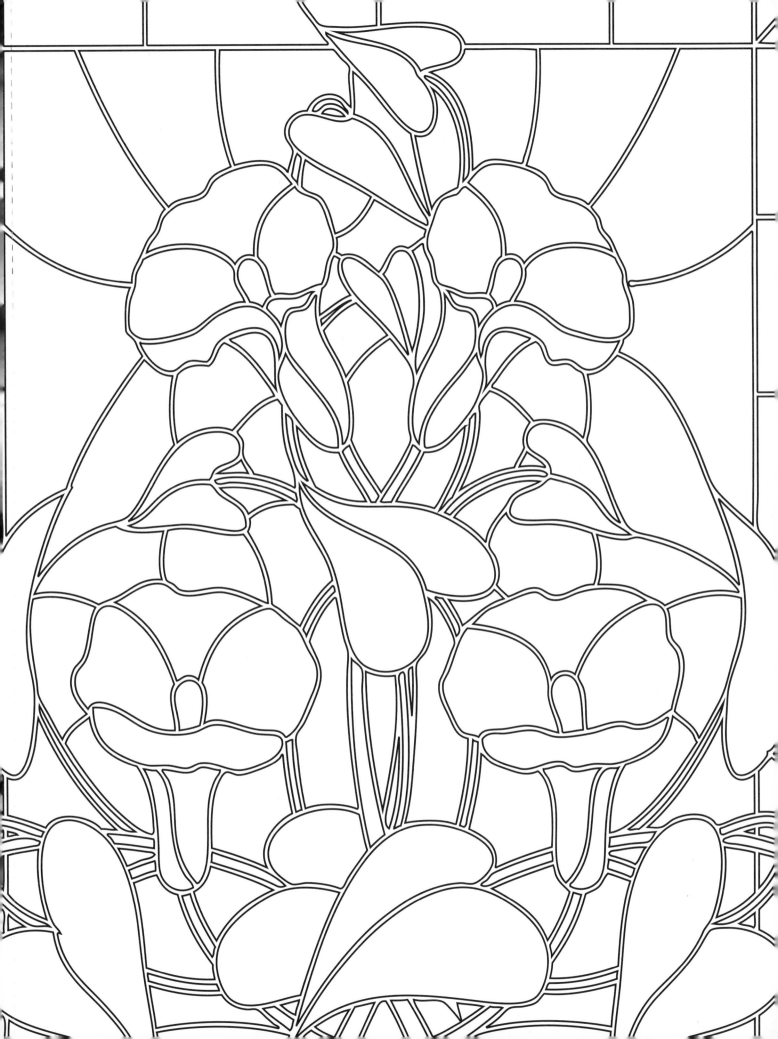

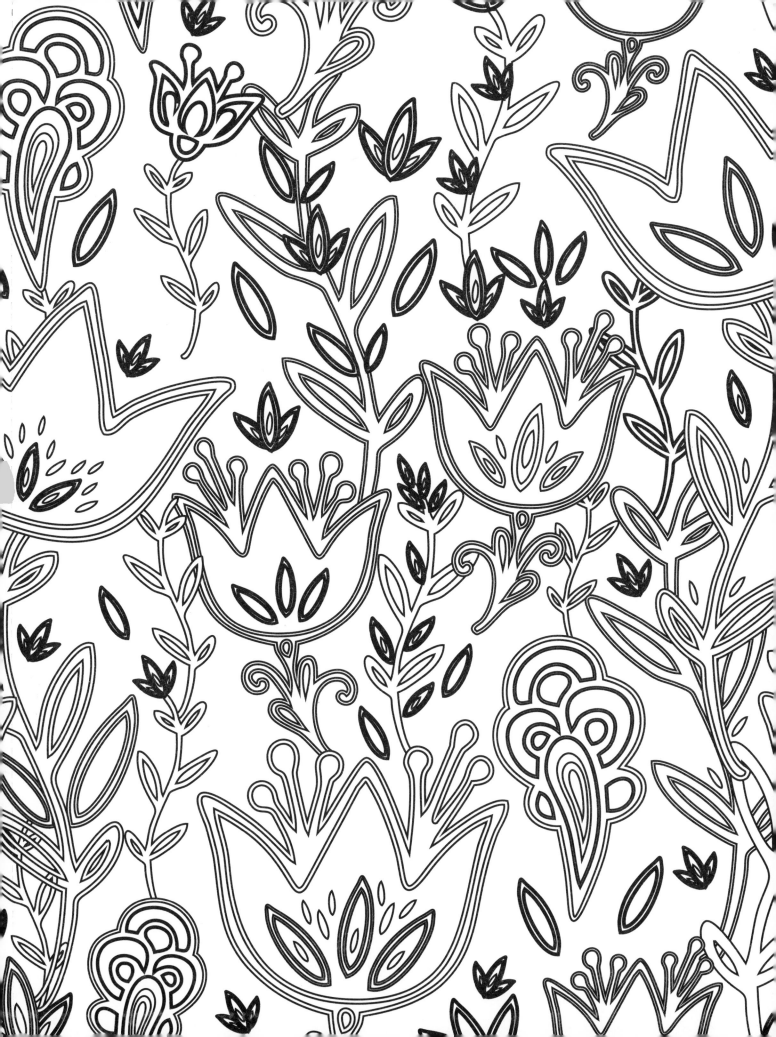

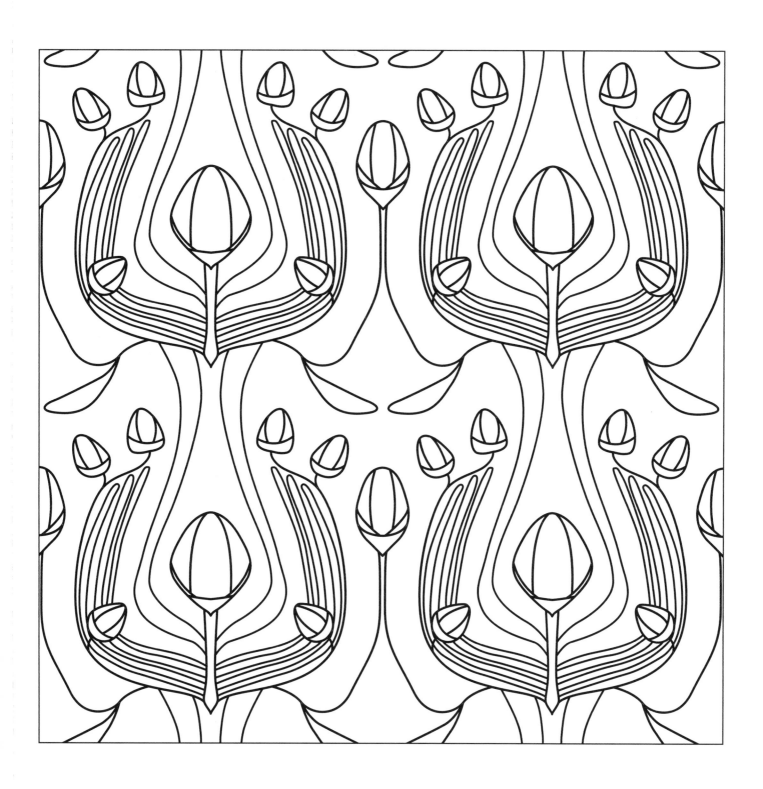

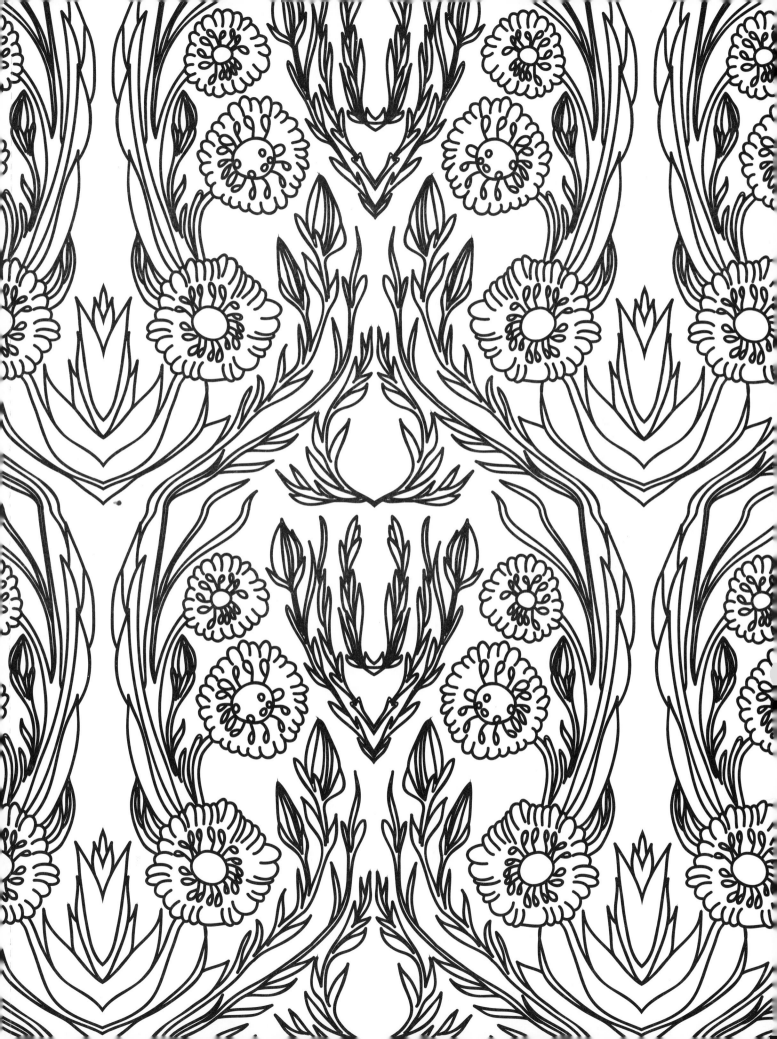

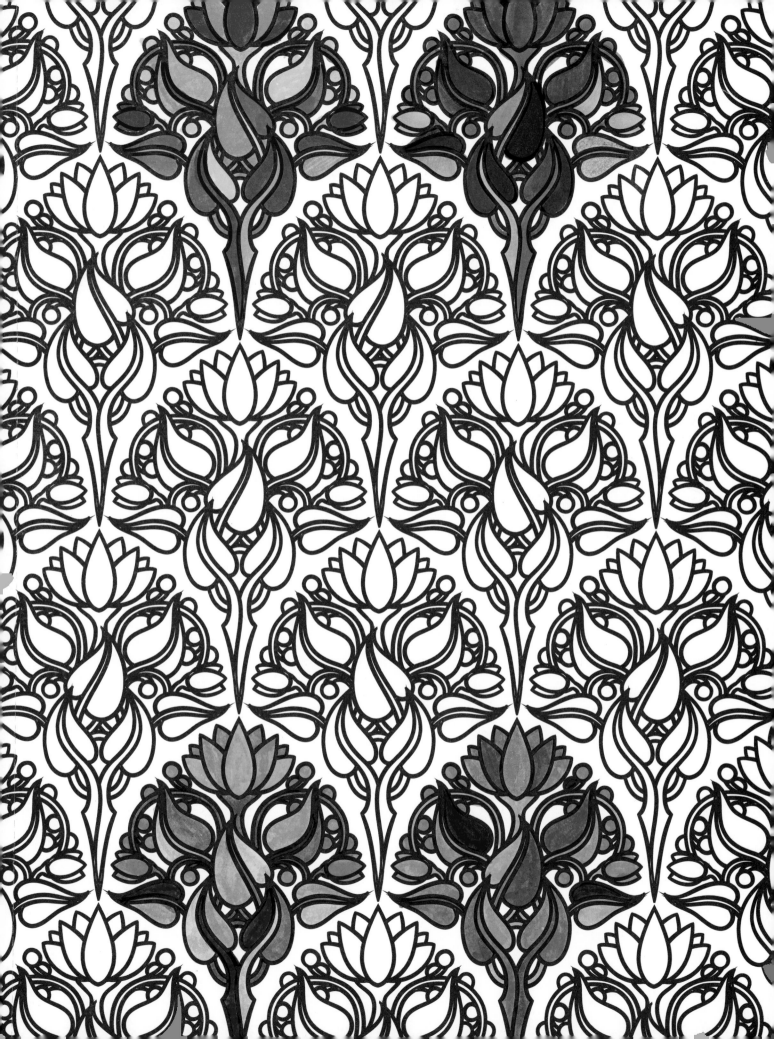

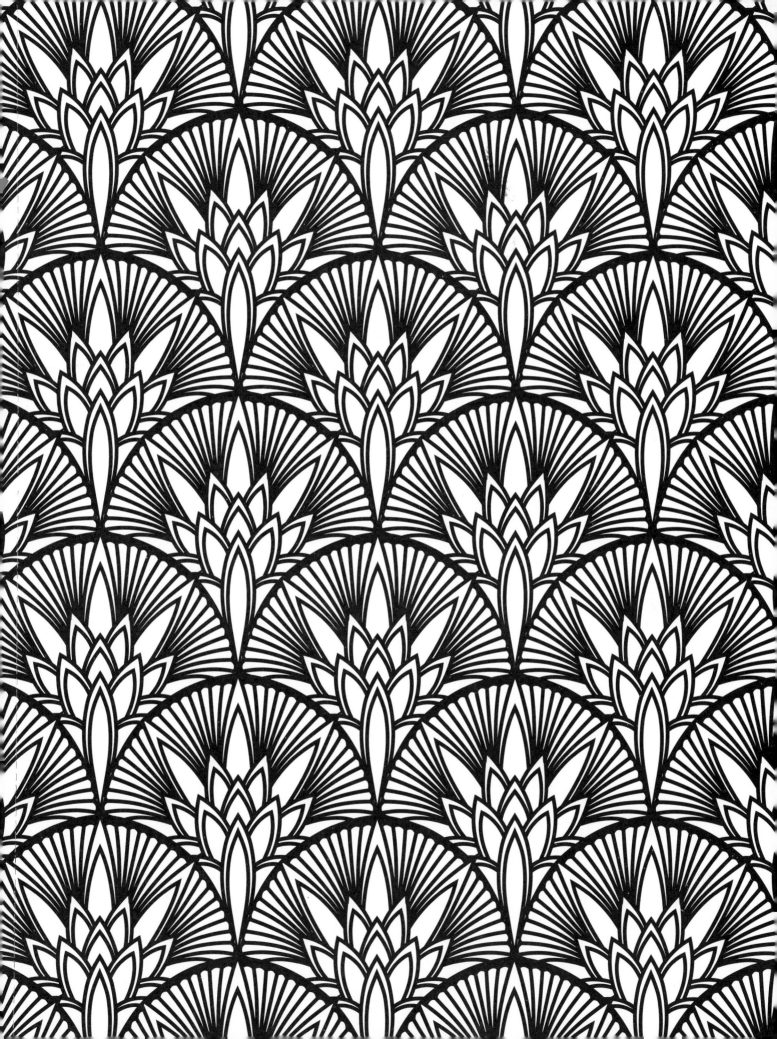

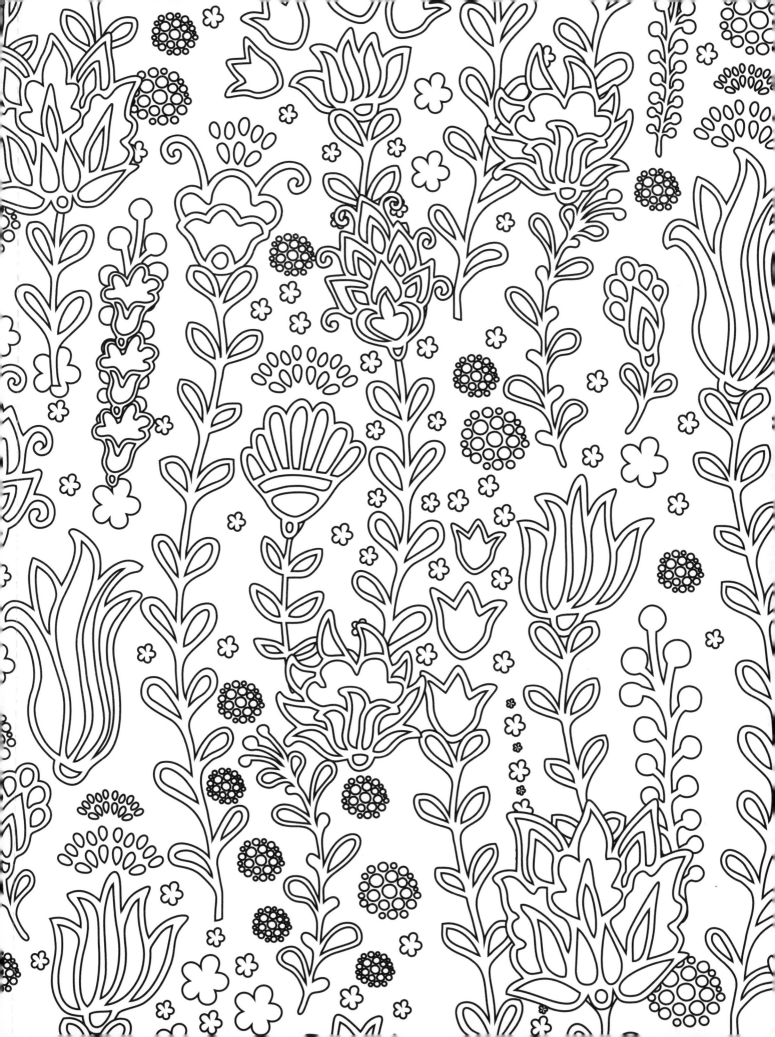

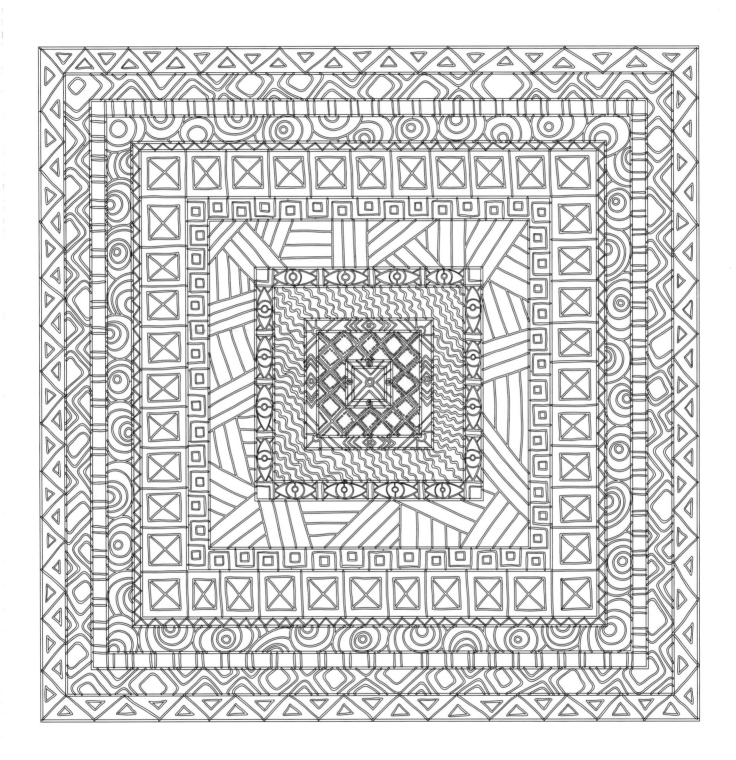

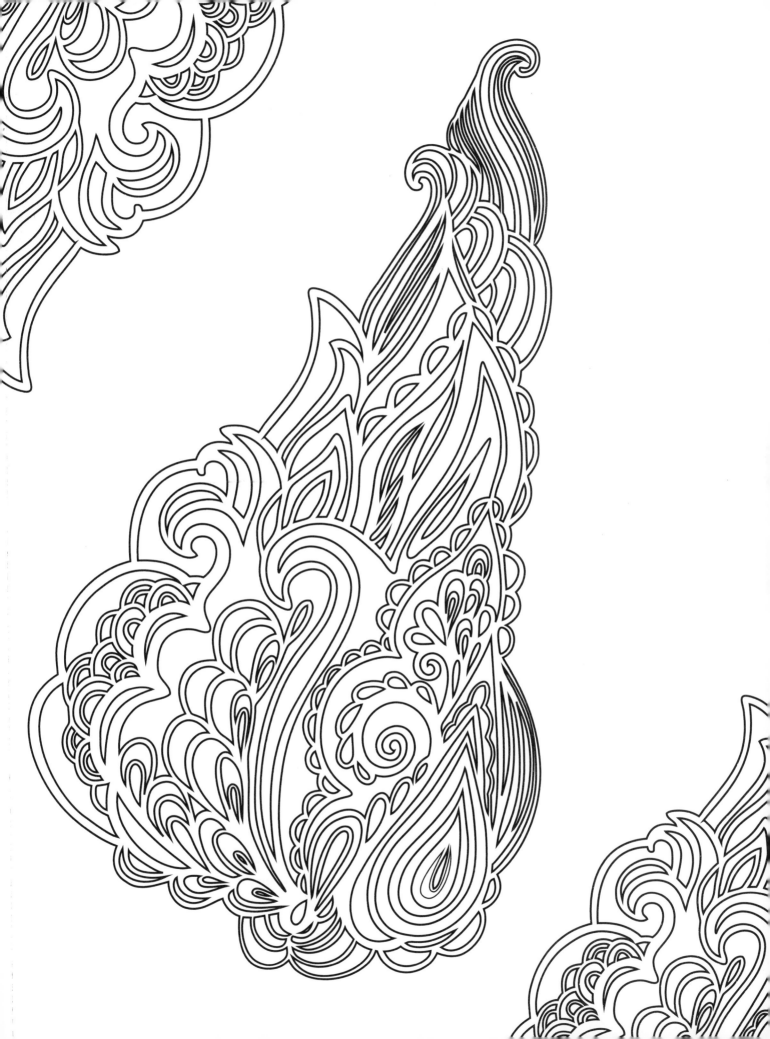

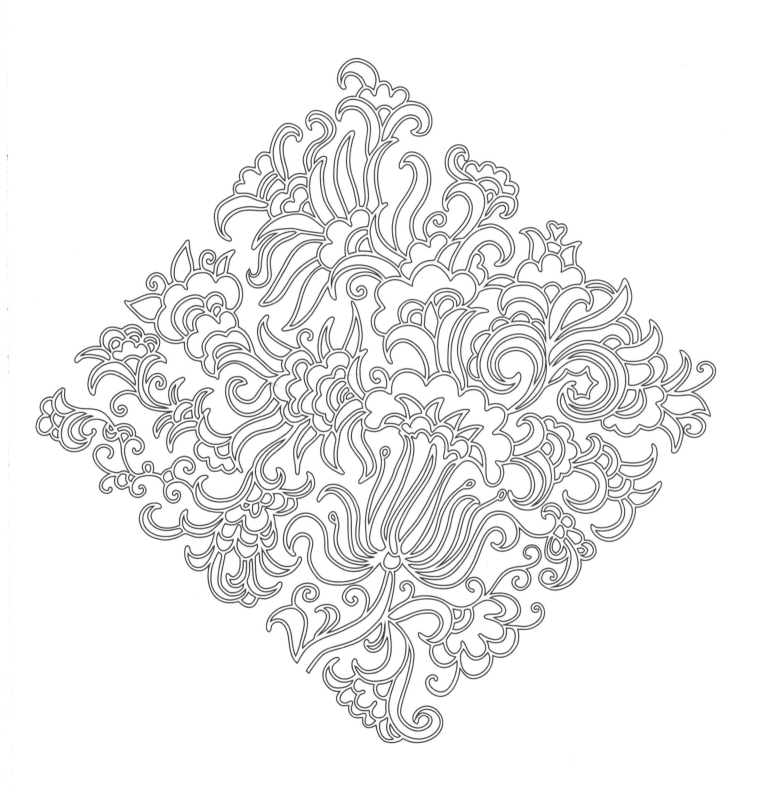

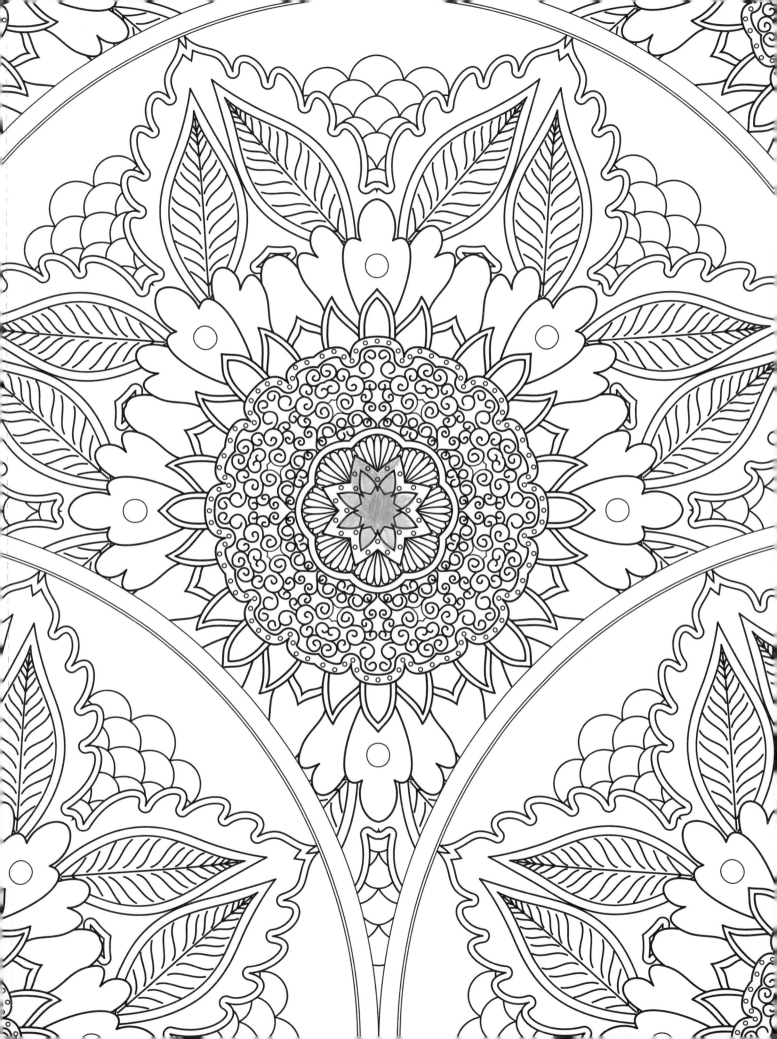

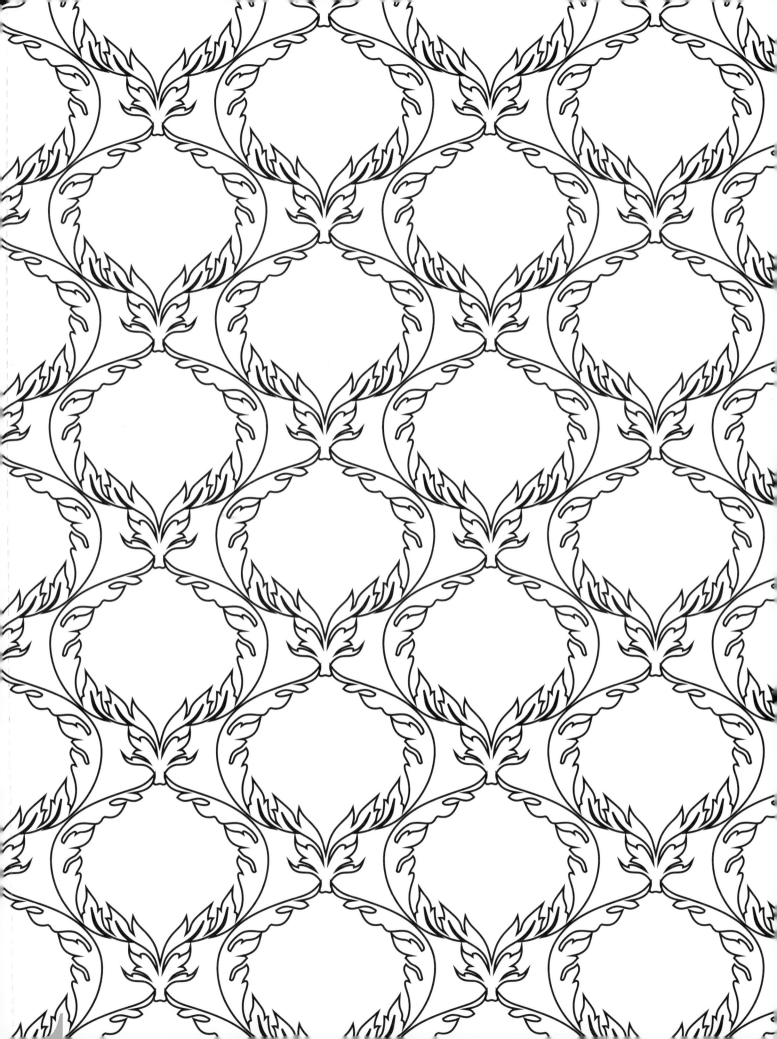

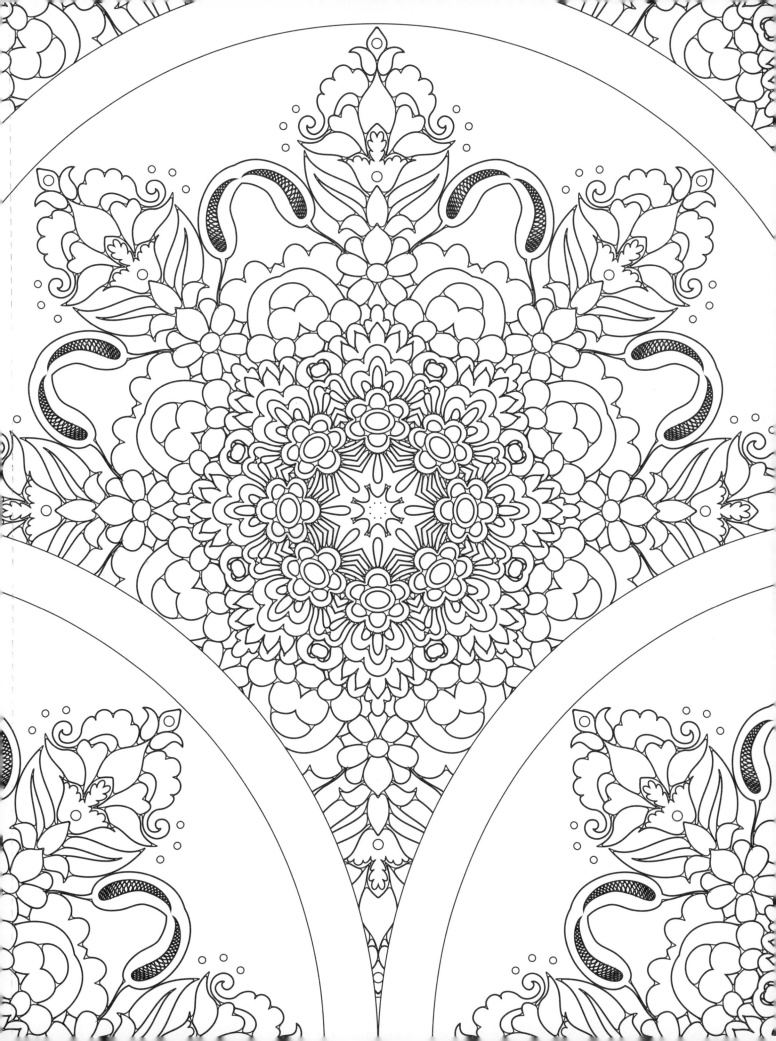

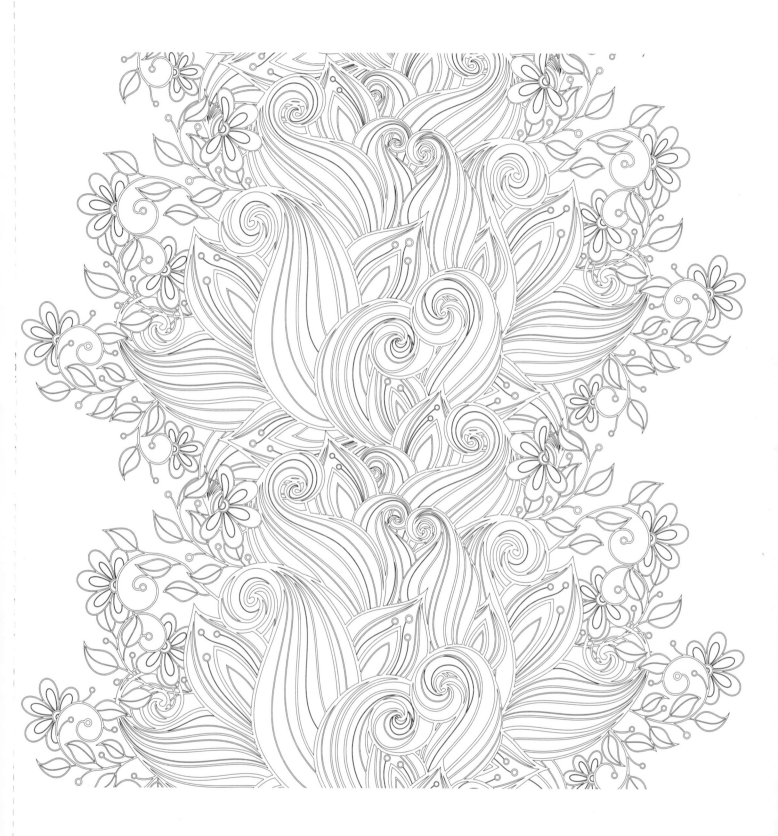

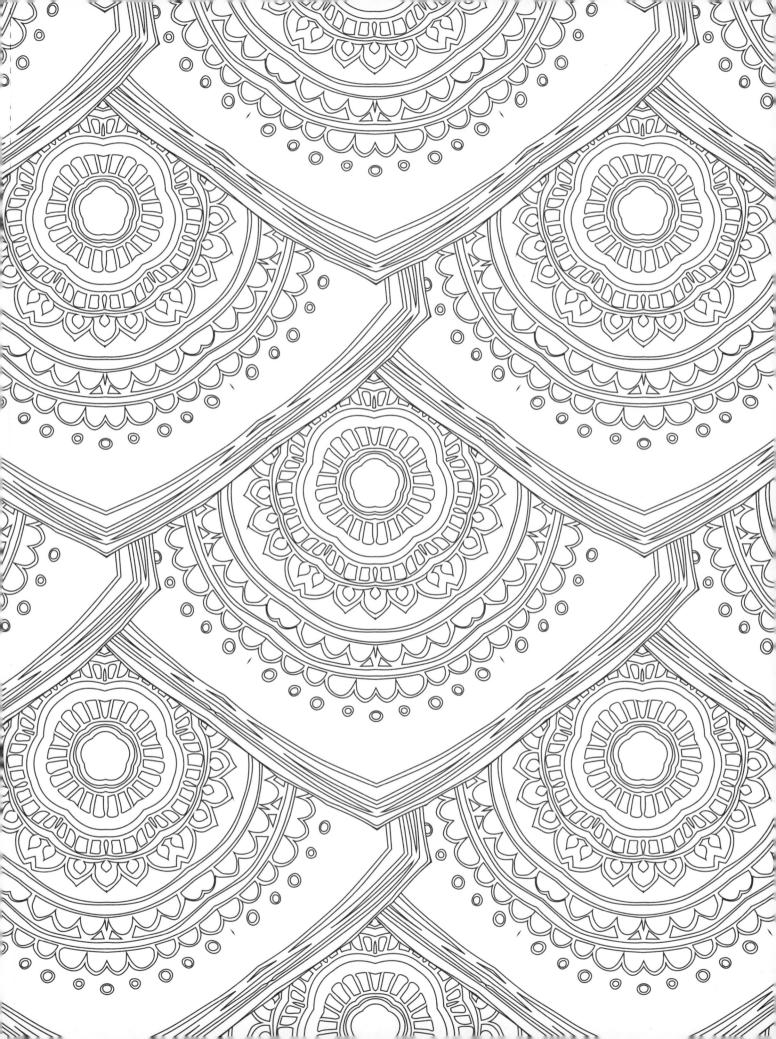

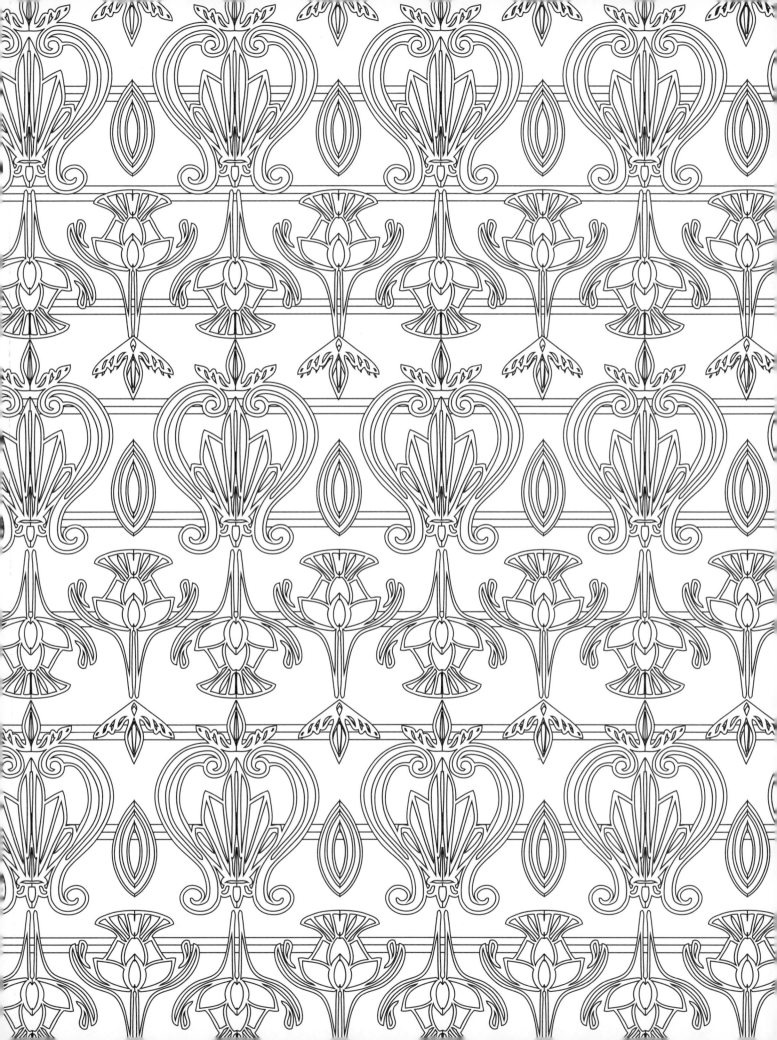

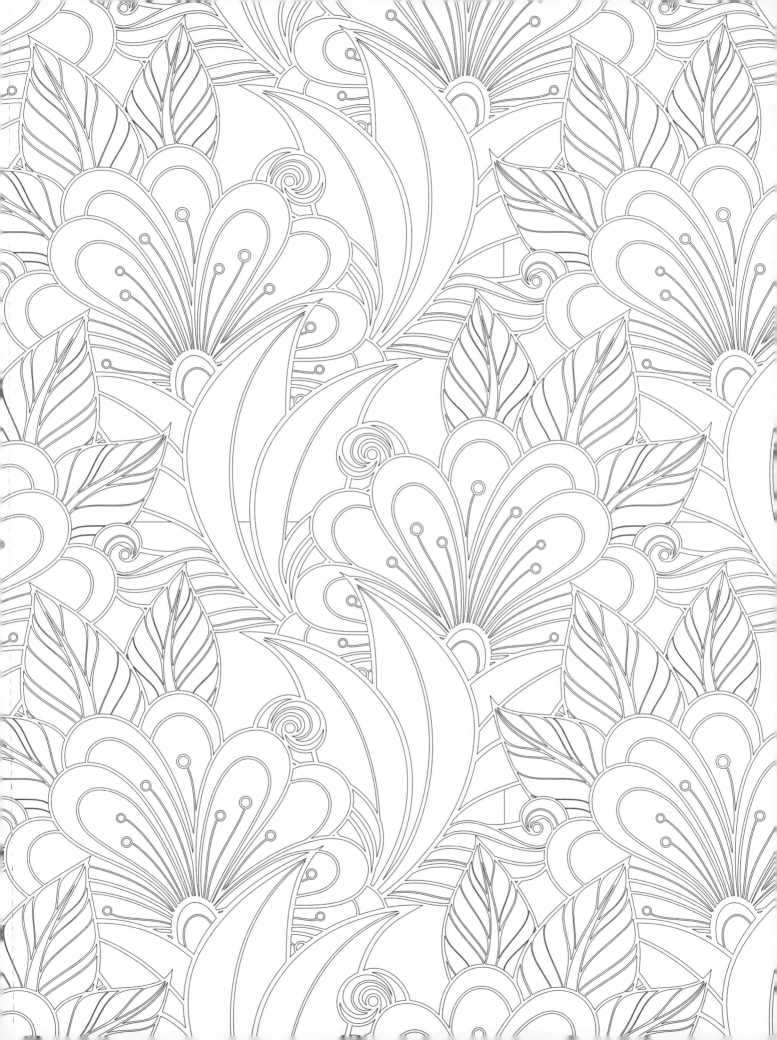

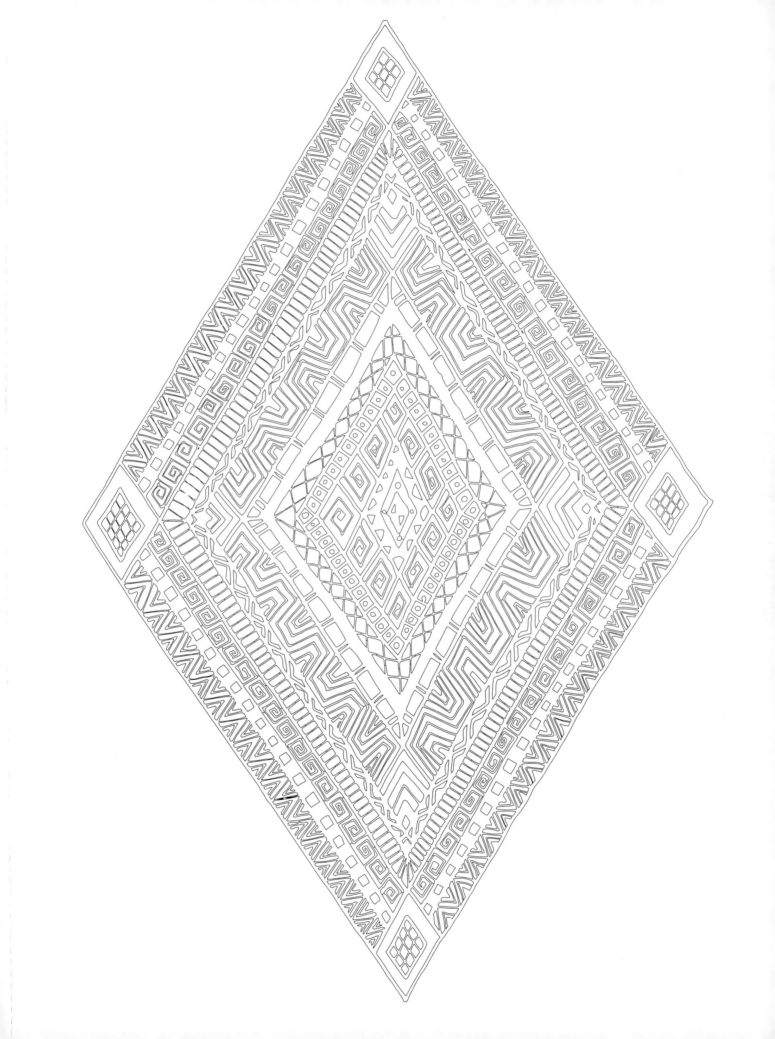

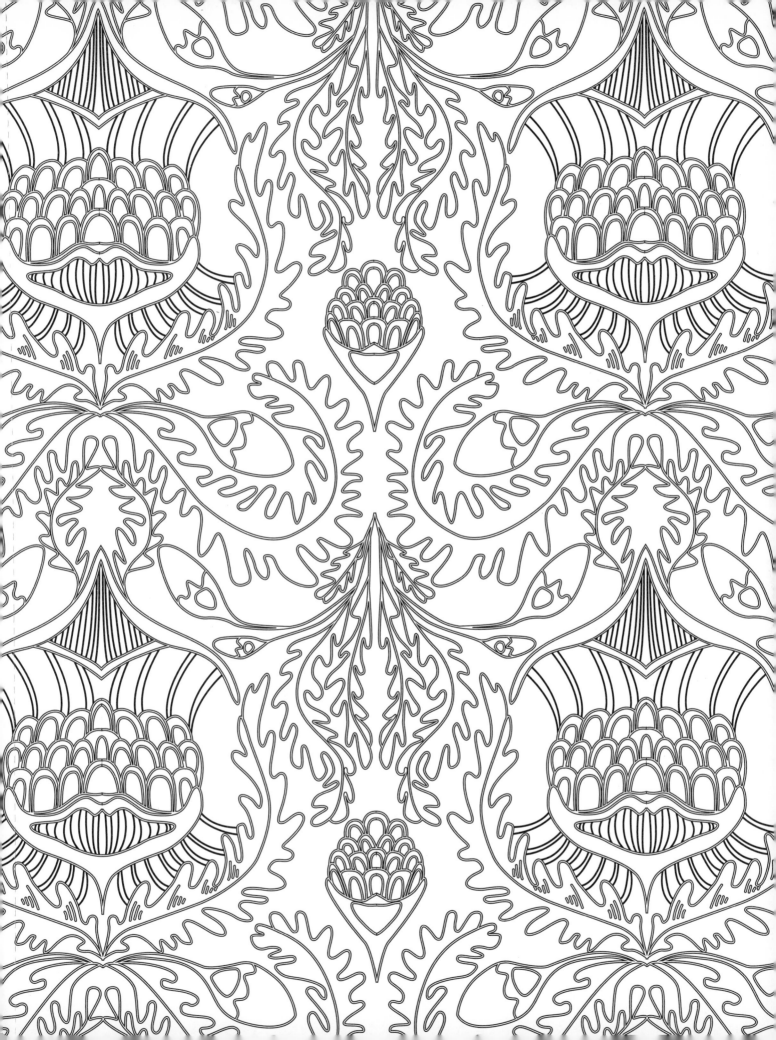

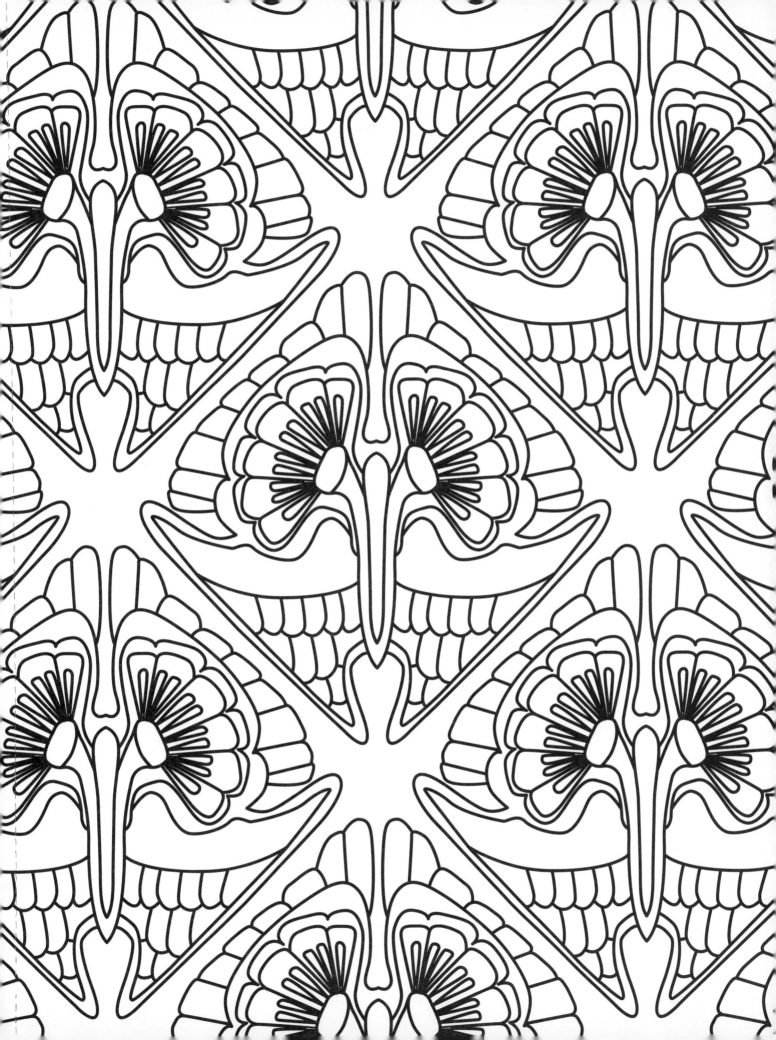

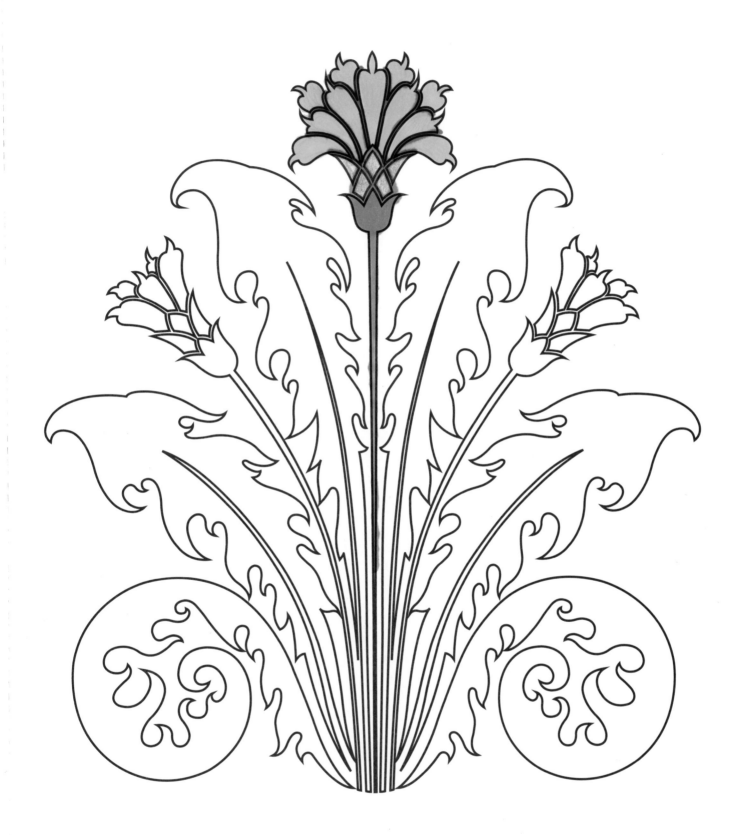

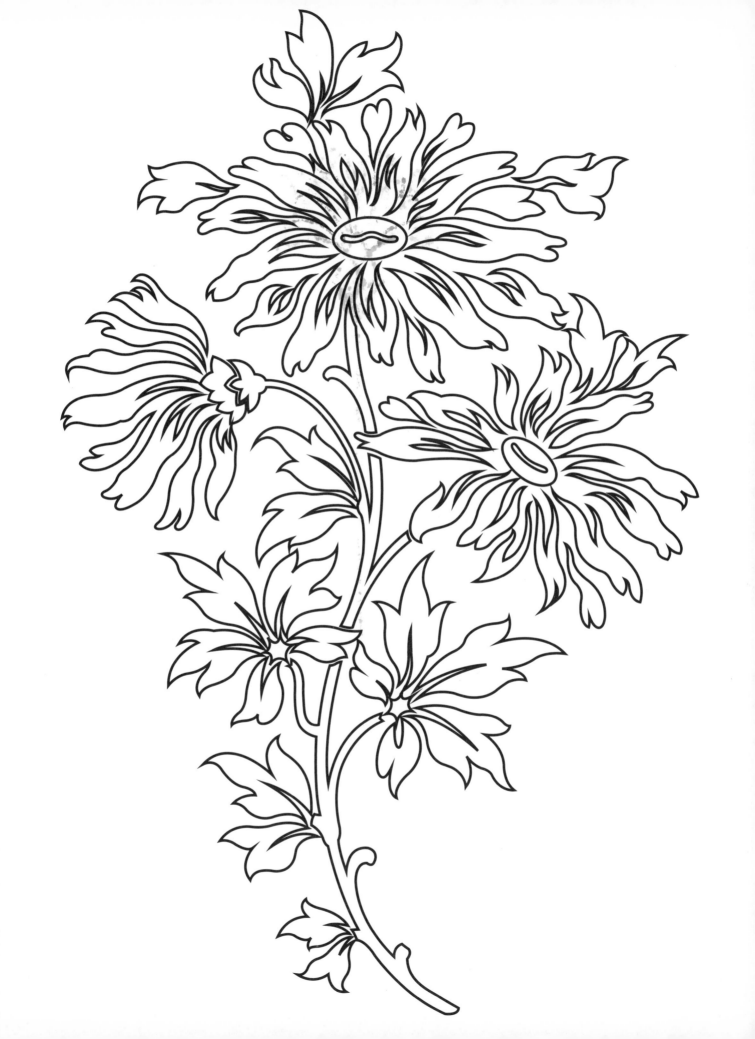

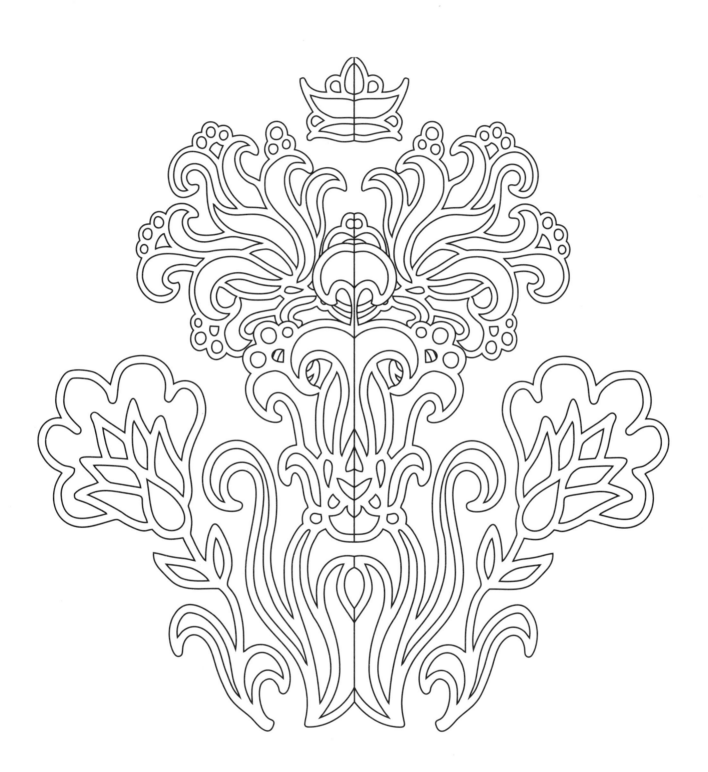

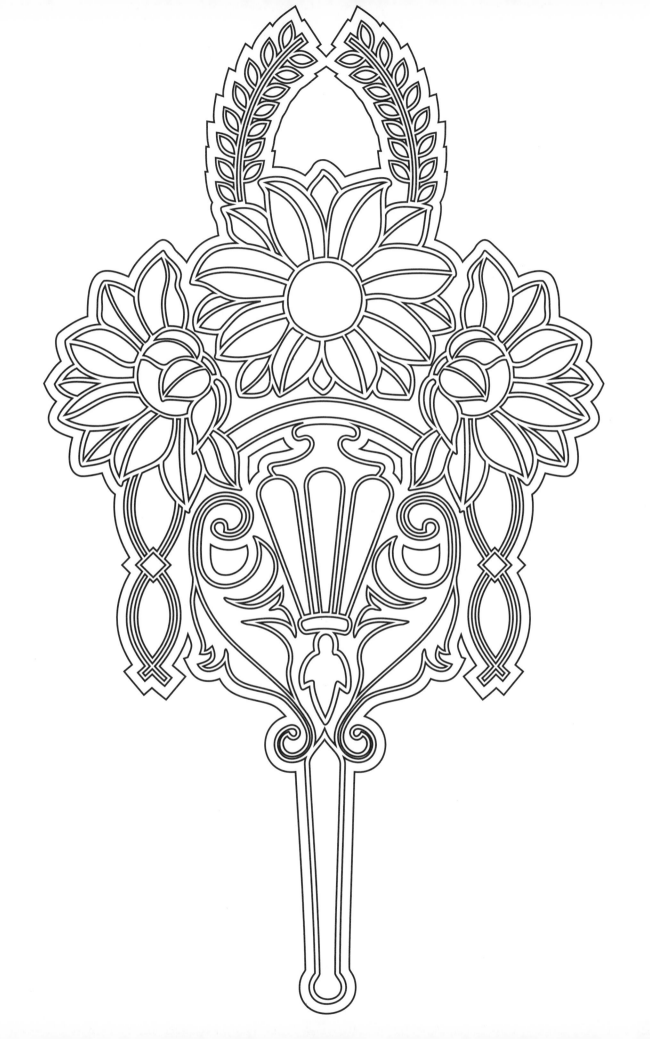

Color Bars

Use these bars to test your coloring medium and palette. Don't be afraid to try unique color combinations!

Color Bars

Color Bars

Color Bars